IMAGES
of America
BINGHAM CANYON

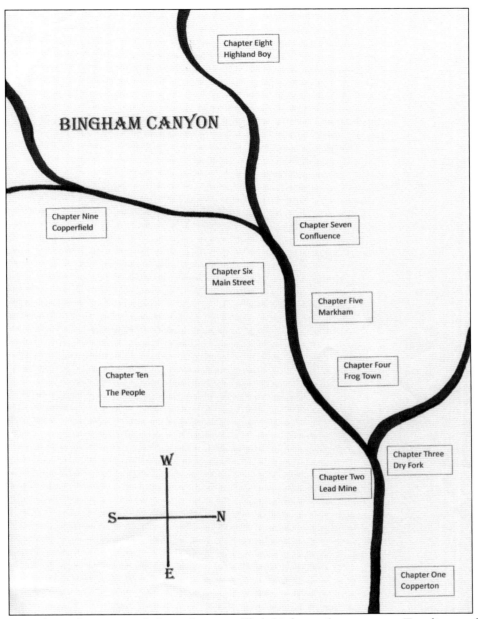

This map shows the towns and places that once filled this large vibrant canyon. Traveling up the canyon, each chapter location has its own story, once crowded with people. The first community, Copperton, is the only place that is left, and the rest of the canyon is now filled in with waste rock or eaten away by Bingham Canyon Mine. (Author's collection.)

ON THE COVER: This image shows the July 4, 1939, parade on Main Street. The people of Bingham loved to celebrate, and on September 30, 1939, they began their own holiday: Galena Days. This photograph was taken at the confluence with the landmarks of the Bingham Mercantile, city hall, and the Copperfield tunnel. This view of the narrow canyon, with the mountains in the background, shows what it was like to live in Bingham Canyon. (Courtesy of Don Strack.)

Tim Dumas

Copyright © 2024 by Tim Dumas
ISBN 9781-4671-6127-5

Published by Arcadia Publishing
Charleston, South Carolina

Printed in the United States of America

Library of Congress Control Number: 2023950649

For all general information, please contact Arcadia Publishing:
Telephone 843-853-2070
Fax 843-853-0044
E-mail sales@arcadiapublishing.com

Visit us on the Internet at www.arcadiapublishing.com

To my mother, Billie Jean Nichols, who was born on top of the mountain at Bingham Canyon. Thank you, Mother, for your love and passion for Bingham.

Contents

Acknowledgments		6
Introduction		7
1.	Copperton	9
2.	Lead Mine	21
3.	Dry Fork	31
4.	Frog Town	45
5.	Markham Gulch and Schools	57
6	Main Street	69
7.	The Confluence	81
8.	Highland Boy	93
9.	Copperfield	105
10.	The People	117

Acknowledgments

First, I would like to thank my sweet wife, Kristine, who has put up with my "Tim" disease (the need to be doing something constantly) our whole married life; the 10 years I worked on my HO train layout, based on the workings of Bingham Canyon Mine; and the hours I put into each of my YouTube videos about Bingham. A special thanks to Don Strack for his passion for railroads, especially for the Bingham Canyon Railroad, and for sharing his vast knowledge and the many images he has collected over the years. Many of the images found in this book were saved as they were being discarded when the mine changed management from Kennecott Copper to British Petroleum in the 1980s. People like Larry Sax, Berry Skinner, and many others went out of their way to save documents and photographs, some saved right out of the trash. The history of Bingham Canyon is loved by many people, and the people who lived and worked there have shared their stories and photographs over the years. These are a few that must be recognized: Steven Richardson, Stella Saltas, Langford Lloyd, Bev Kennedy, Jesse Ross, Erma Yengich, Joe Lugo, Eugene Halverson, Michael Ann Scroggin, Wilbur Smith, Eldon Bray, E. Larry Osoro, John Creedon, Brad Allen, Vern Abreu, James Belmont, Marion Dunn, Steve Swanson, Gordon Bodily, Rudy Lund, Andy Pazell, Scott Crump, Gaell Lindstrom, and Shirl Scroggin, to name a few. Thanks to the people of the Bingham Canyon History Facebook group, all 9,000, and growing, so willing to share stories and pictures of Bingham. Thank you to all who purchased this book, as doing so helps keep Bingham's history alive. Please tell your children and children's children that once there was a place like no other—Bingham Canyon. All images are from Don Strack's collection unless otherwise noted.

Introduction

Bingham Canyon is now buried under thousands of tons of waste rock. Its history is fading into the past. That history is unique, from a rough and tough mining camp to a large open-pit mine. Bingham Canyon would either be buried or eaten away by the expanding open-cut mining operation, now so vast it can be seen from space. The name came from the Bingham brothers, Thomas and Sanford. In 1848, they were sent to the canyon to tend and graze horses and cattle belonging to Brigham Young. Brigham Young was the prophet of the Church of Jesus Christ of Latter-day Saints (the Mormons). With his direction, the Latter-day Saints entered the valley in 1847. The Latter-day Saints needed a strong leader to survive in this harsh environment, and they had one with Brigham Young, "the Lion of the Lord." The Bingham brothers moved from the canyon, but the name remained. The story goes that the Bingham brothers found precious minerals at Bingham but were told by Brigham Young that "such enterprise would surely have a degrading effect upon all who engaged in it."

The mountains the Bingham brothers left behind were filled with gold, silver, and copper. The riches would have to wait until 1863 with a new discovery. One story of the ore's discovery was that a logger, George B. Ogilvie, noticed shiny stones dug up by a dragline while pulling logs down the mountain. The loggers took the stones to Archibald Gardner, the log mill's owner, who advised them to take the samples to Col. Patrick O'Connor, Fort Douglas commander. Determining that the stones were ore, the loggers, Gardner, the officers, and Colonel O'Connor set up a meeting and organized the Mountain West Mining District and the first claim at Bingham on September 17, 1863, the Jordan Silver Mining Company. Col. Patrick O'Connor encouraged his soldiers to prospect the mountains on their off hours around the territory. Colonel O'Connor wanted to break up the Mormon monopoly by bringing outsiders into the region.

With the discovery of gold, silver, and lead at Bingham came a flood of people. The mountains around northern Utah (territory back then) were filled with prospectors looking to strike it rich. In the Wasatch Mountains, places like Alta and Park City, and in the Oquirrh Mountains, Ophir, and Bingham, ore was discovered. Mines came and went; without adequate transportation, the early mines faltered. Finding ore in the ground was one thing, but getting it to the smelter was another. With the coming of the transcontinental railroad in 1869, then spurs by way of the Bingham Canon (old spelling) & Camp Floyd Railroad to Bingham Canyon in 1873, the slumbering mines came alive. By 1900, there were over a thousand claims filed at Bingham, and the mountainsides were spotted with mine dumps.

These early miners mined gold, silver, and lead; the specks of copper they found in the rocks were considered a nuisance. It was the turn of the 20th century, and the demand for copper was coming. A few men saw the potential of the mountain of low-grade copper ore. Enos Wall and Samuel Newhouse started to buy up old claims, but it was not until two young mining engineers, Daniel Jackling and Robert Gemmell, ran tests on the low-grade copper ore that its possibility was realized. Their idea was to mass produce this low-grade ore—the first time this method had been

done with copper. In 1906, both Utah Copper and Boston Consolidated Copper started open-cut mining. They merged in 1910.

This is where the story of Bingham Canyon really takes hold. The new process of mining copper using large steam shovels and trains was labor-intensive, and with the mines' growing success, more and more employees were needed. That meant these men needed a place to live, eat, and sleep. Bingham, Highland Boy, and Copperfield became home to thousands of workers. Underground mining was still active and needed laborers. These underground mines had been going on from 1863 to 1906, so 43 years before open-cut mining started. The old Bingham mining camps had a rough and tough reputation, along with many bars, gambling, and red-light activity. The large new mining companies wanted a reliable workforce and to break away from the bad reputation Bingham had. With the many women working in the hotels and boardinghouses and men wanting their families with them, the company started building better housing. A large group of nice company houses and apartments were built in Copperfield and then in the community of Copperton.

The insatiable demand for workers brought in people from all over the world. Bingham would be called a "League of Nations." A need for cheap labor brought a flood of immigrants to the mine. Bingham Canyon became the most ethnically diverse place in the state. By 1912, sixty-five percent of Bingham's population was foreign-born. Greeks were the predominant nationality, followed by Italians and then Serbs, Creates, Slovenes, and northern Europeans. Each group had its own stores and restaurants; they brought with them their own customs and religion. The Carr Fork area was home to Norwegians, Swedes, and Finns; in Highland Boy, one would find Southern and Eastern Slavs and Italians. Copperfield was home to Greeks, Japanese, Britons, and Scandinavians. French, Irish, and many more peoples came to Bingham. The people who ever lived in Bingham loved the place. Even years after leaving, people always talked fondly about it. If you once lived there, you were then part of the exclusive club.

Prejudice and discrimination were commonplace at the mine. Names like "Little Italy," "Greek Camp," "Jap Camp," and "Bo Hunk Town" all flourished at the mine. The company was guilty of giving lower pay and labor-intensive jobs to different nationalities. Over time and with the help of the unions, this trend started to change. The prejudice even went as far as only letting certain people move into the companies' town of Copperton. The children were the big game changers about prejudice; going to the same schools and playing together, it was the children who started to change people's attitudes and brought everyone together. Men working together day to day made a connection and then a bond. Living together in this tight, narrow canyon, one learned to love and respect their neighbors no matter what nationality.

Most people who lived in Bingham did not have much; some of their houses were no more than shacks built with scrap lumber. "Powder box" and wood-frame houses without yards were, on the outside, run down and unkempt; on the inside, the houses were perfectly clean and filled with love. The people who lived here were happy, and they had a common thread of community. They all lived on top of a mountain, and most worked on "the hill" (the name fondly given to the mine), and though they were separated by nationality, race, color, or religion, they had this common bond of living in this place called Bingham.

The people who lived in Bingham made the place come alive. This is Bingham's truly remarkable story.

One
COPPERTON

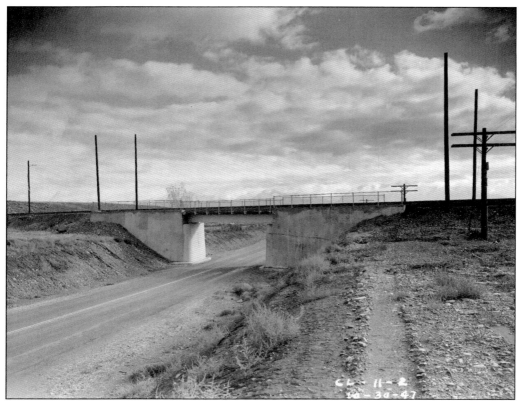

Traveling up Bingham Canyon, the first stop is at the mouth of the canyon in the little community of Copperton. The cement train overpass is the gateway into Copperton, built in 1947 as part of the new railroad line to the mills, the Copperton Low-Line. The first train of empty ore cars entered Copperton Yard on May 12, 1948, just south of the overpass at right.

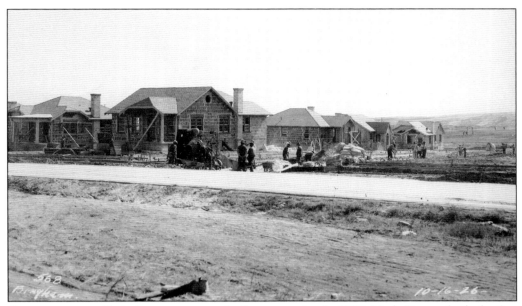

Copperton was a Utah Copper company-built community. In 1926, Utah Copper built the first 18 homes. In 1927, Utah Copper built 30 more homes, and then construction came in stages over the years, adding up to 204 homes, with the last 14 built in 1941. Utah Copper became Kennecott Copper in November 1936. (Kennecott Copper was heavily invested in Utah Copper when it took control.) Starting in 1949, Kennecott Copper only built duplexes.

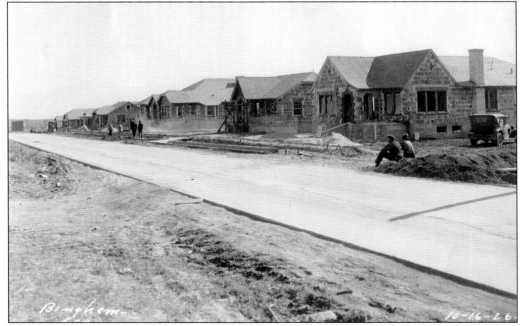

Plans and blueprints for the community and houses of Copperton were being drawn up as early as 1923 by the architectural firm of Scott and Welch. Copperton was Utah Copper company owned and maintained. In this photograph taken on October 16, 1926, note the old car and, to the right, two men taking a break. Workers are putting in new sidewalks down the street.

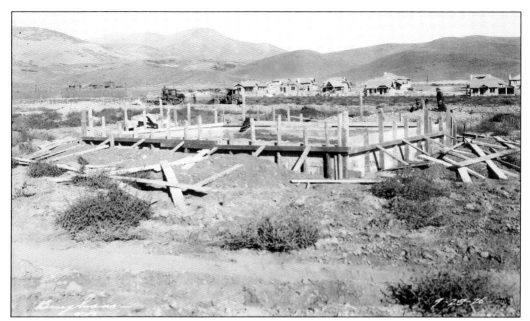

Forming foundation walls for a new Copperton house, the lumber was reused for building the home. Copperton was built by Utah Copper to break away from the rough and tough reputation of Bingham's mining town. A newspaper advertisement said, "Copperton will be a town of families—there will be no room for a floater, the pool hall habitue, or the bootlegger."

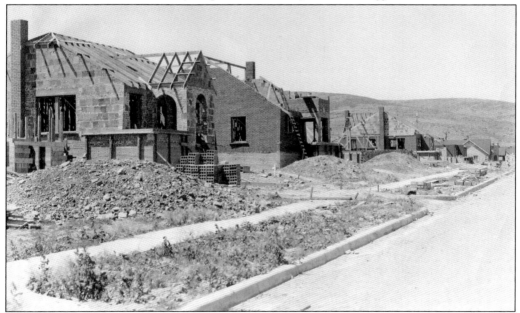

With the construction of the Copperton homes, the four-room house cost $5,065 to build, and the five-room model was $5,804. The mine's superintendent house cost $18,983 to build. Rent for the four-room house was $22.50 a month and a five-room was $27.50 a month. The pay scale per day in 1926 was $6 on the high end and $3.50 on the low end. The house exterior was stucco or brick; note the heavy block work on the first house for a stucco exterior.

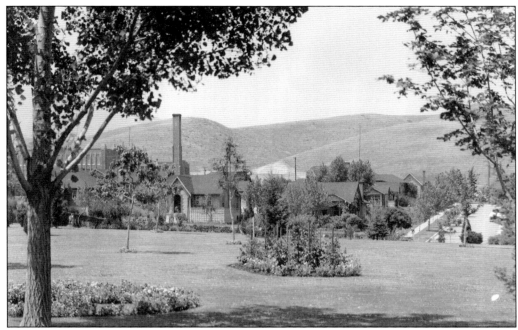

In the center of Copperton is this beautiful eight-acre park. Developed in 1927, it was landscaped with grass, trees, flower beds, winding paths, a bandstand, restrooms, tennis courts, and a playground. At one time, it had a full-time gardener. The photograph is looking northwest, with Bingham High School in the background to the left. Note the picturesque tree-lined street to the right.

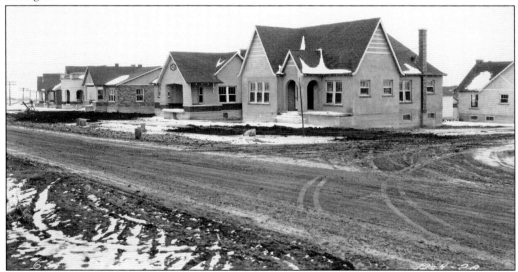

From the beginning, Copperton houses were in great demand, and only certain people could get a home in Copperton. Priorities were company officials, mid- or upper-level management, and foremen. Skilled workers, such as steam shovel operators, railroad engineers, or workers with a similar status, were on top of the list for a Copperton home and were determined by the amount of seniority they had. Only married couples could live in Copperton. Employees had to move out if they retired, quit, or were widowed.

Copperton homes were well built with central heating, indoor plumbing, detached shared garages, and a breakfast nook. Copperton houses were constructed with copper shingles, rain gutters, downspouts, piping, brass fittings, and even brass screens on the windows and doors. The Utah Copper company wanted to advertise its own copper products. The photograph shows one of the four houses that was totally built with copper, even with the prefabricated walls with siding.

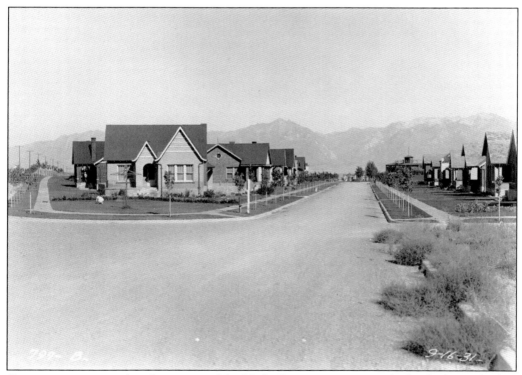

Copperton was owned and maintained by Utah Copper company. It had a high standard of appearance inside and out. Every couple of years, Utah Copper would come in and paint or wallpaper—just ask an older resident who had to strip years of wallpaper off. The homes had half basements to save on tax assessments, and most residents dug theirs out into a full basement.

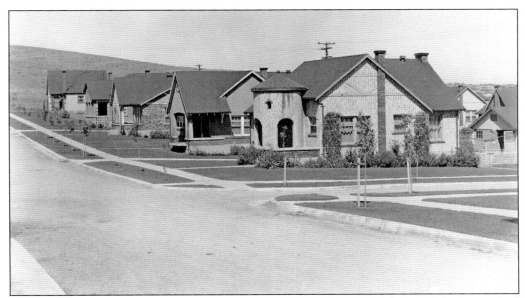

The landscaping of the Copperton homes was the residents' responsibility, and the houses had to have a nice appearance. Gary Curtis told the story that Louis Buckman (mine superintendent from 1930 to 1946) would drive around inspecting homes in Copperton, and if they were not up to par, such as full of weeds or an unmowed lawn, he would dispatch employees from the mine to clean it up, and the resident would get the bill.

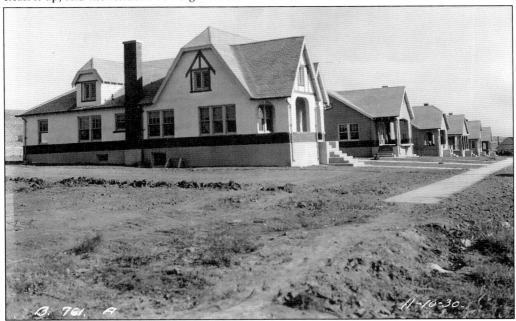

One of the nicer homes in Copperton was built for Dr. Russell G. Frazier, who worked out of Utah Copper's hospital (known as the clinic) in Bingham. He came to Bingham in 1918 to assist Dr. Ray and later took over that position. Dr. Frazier was an avid sportsman and a civic leader in Bingham. From 1938 to 1944, Frazier was the physician in Rear Adm. Richard E. Byrd's Third Antarctic Expedition.

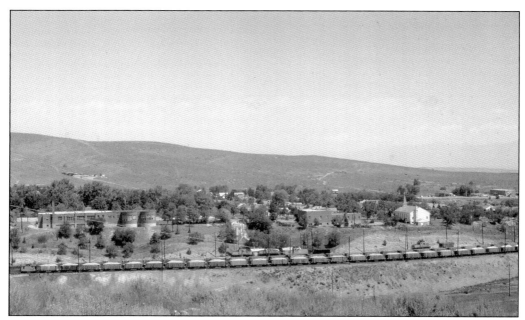

The Copperton railroad yard was built as part of the new ore haulage line to the mills in 1948. It was a crescent-shaped yard that wrapped around the town. Loaded ore cars came in from the mine at one end and then exited at the other end. Copperton yard was below the town along a gulch. Residents who lived in Copperton said they never heard the trains, and they worked night and day.

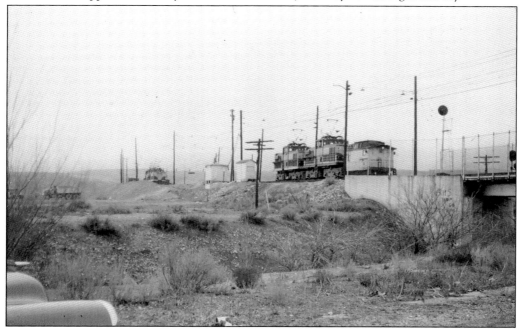

Two large Magna locomotives and caboose approach the cement overpass entering Copperton yard. The overpass was the indicator where the big electric Magna locomotives could pick up their higher voltage (3,000 volts DC) trolley line. Copperton yard trolley lines were 750 volt DC to run the smaller electric locomotives that were used in the mine.

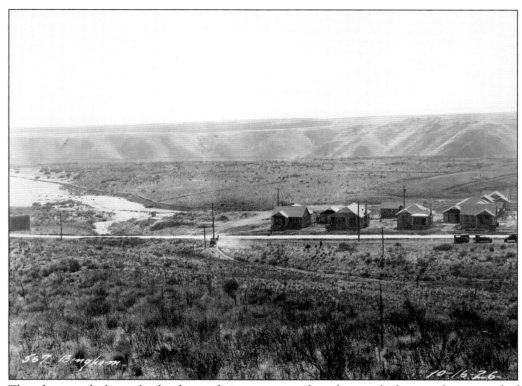

This photograph shows the first houses being constructed on the state highway at the west end of Copperton. The northeast section of Copperton houses was built on an old mill dump site. The tailings, or gangue, from the old mill were finer than sand; to build the houses at this end of town, construction crews had to sink long piles into the soft ground to construct the house footings on.

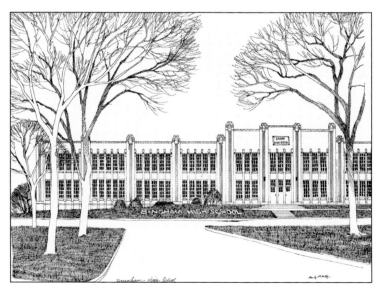

Bingham High School, after three locations up in Bingham, moved down to Copperton in 1931. It was designed by the same architecture firm of Scott and Welch, which planned the community and blueprinted the homes for Copperton. The building cost $350,000 to erect. The people loved the look of this school. In 1975, Bingham High School moved for a fifth time to South Jordan. (Courtesy of Marilyn R. Miller.)

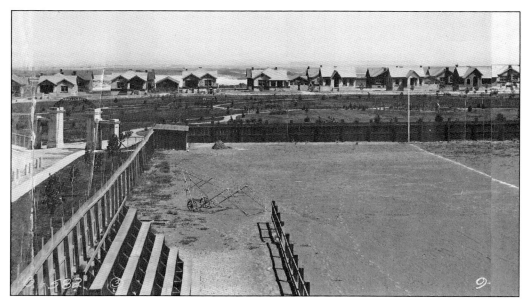

The people of Bingham loved baseball, like most folks around that time. With no room up in Bingham, Utah Copper built a large ballpark in Copperton. It was located west of the park. With a tall fence and bleachers, it was built around the same time as the first houses in 1926. With the help of the Works Progress Administration (WPA), a new baseball field was constructed behind Bingham High School in 1938.

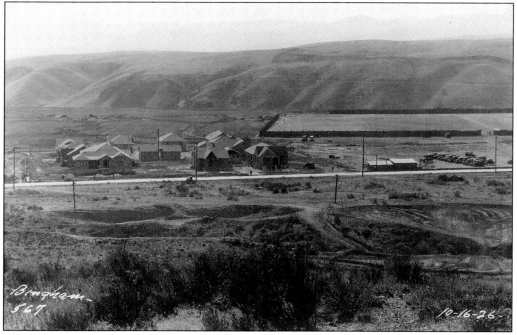

This early picture of Copperton is dated October 16, 1926, and shows the first homes being built. The large baseball field is center right. Grading for the new Copperton park is taking place, next to the baseball field. In 1955, the Kennecott Copper company sold all the Copperton homes to real estate firms, and in turn, they sold them to the residents at an affordable price.

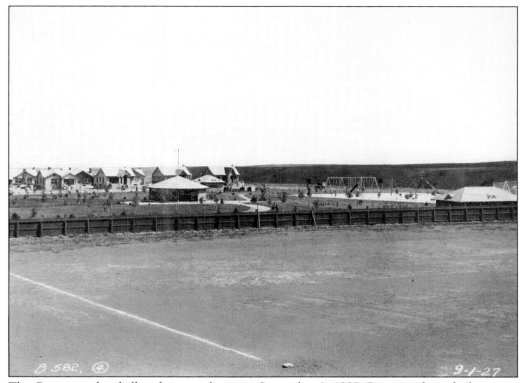

The Copperton baseball park is seen here on September 1, 1927. Running through the center of the photograph is the newly landscaped Copperton Park. Note how small the trees are and the pavilion and playground. Above the park, houses are being built on Gemmell Club Street. After the ballpark moved behind Bingham High School in 1938, that area was developed with more Copperton homes. It included Park, Cyprus, and Hillcrest Streets.

This image shows the first church in Copperton, the Church of Jesus Christ of Latter-day Saints, built in 1942. Of note is that some of the bricks used to build the chapel were from the old Yampa smelter that was in Frog Town. The second was the Methodist church; it was moved up to Copperton from Kearns Army camp. The third was the Catholic church on the state highway, built in 1949.

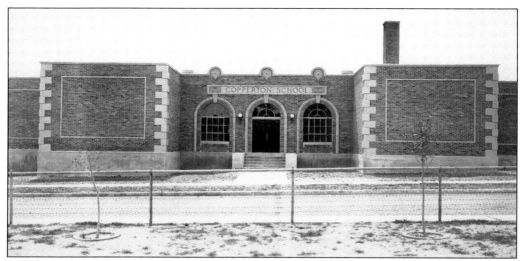

Copperton Elementary School was built in 1929 at the south end of town (it is now demolished). There were only a few businesses in town. There were apartments when one first entered the town as well as a gas station, a café, Copperton Market, and Utah Copper Credit Union. These would change over the years, becoming different things.

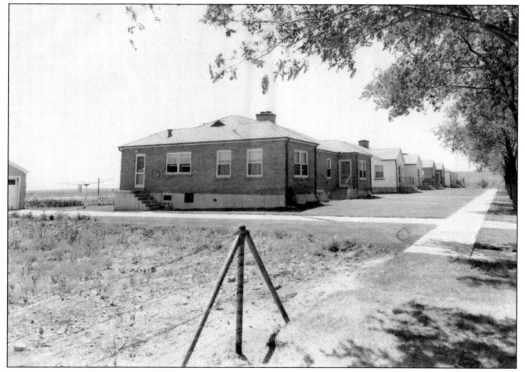

When entering Copperton at the east end of town, Kennecott Copper constructed a new street and built several new duplexes. This took place in the late 1970s after years of no new construction. The homes were primarily built for the people of Lark, Utah. Kennecott purchased all the properties around Lark to expand dumping grounds. The new duplexes were built for that displaced community.

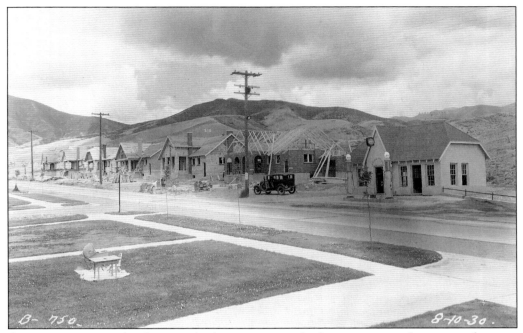

Copperton was not the first nor the largest company-built mining town, but it was the most substantial and well-furnished group of houses, with 85-plus design variations. This photograph dated August 10, 1930, shows the small gas station. Houses were under construction, and where they ended, the new Bingham High School was built in 1931.

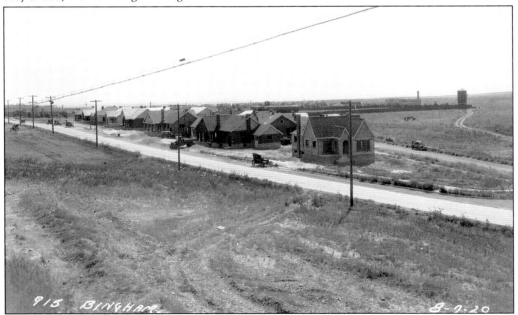

This view is looking down the state highway as it passes by Copperton, heading up Bingham Canyon. The photograph is dated August 7, 1929. Copperton is the only reminder of Bingham, the last vestige of that thriving canyon. Come and visit Copperton, drive up and down the streets, and have lunch at the park—it will convey a distinct sense of time and place.

Two

Lead Mine

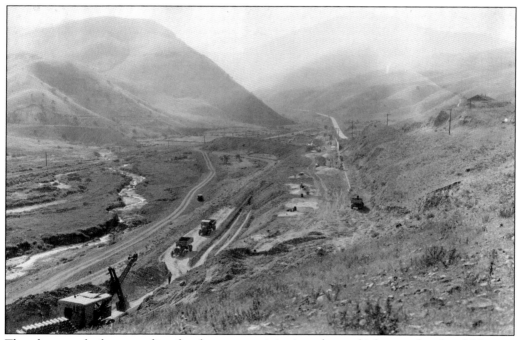

The photograph shows grading for the new precipitation plant, which moved to Lead Mine in 1929. Lead Mine was the next small community moving up Bingham Canyon. Copperton was on a bluff, and the road from Copperton traveled downhill to reach Lead Mine. The name for Lead Mine came from an old lead mill that was once here. The mill serviced the mines on the east side of the Oquirrhs, like the Yosemite and Keystone mines.

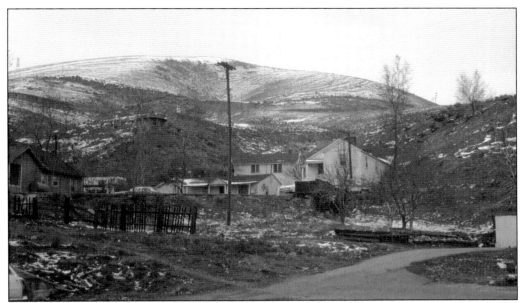

This image of Lead Mine on April 27, 1973, shows houses scattered along the hillside. There were just a few houses and businesses at Lead Mine. One of the businesses was a bar, the Moon Light Gardens, a favorite spot for thirsty miners on the way home from work. The next two buildings will change over time to a café, a pharmacy with a soda fountain, a liquor store, and a safety boot shop. The buildings will later combine to become the Bingham Museum and souvenir shop.

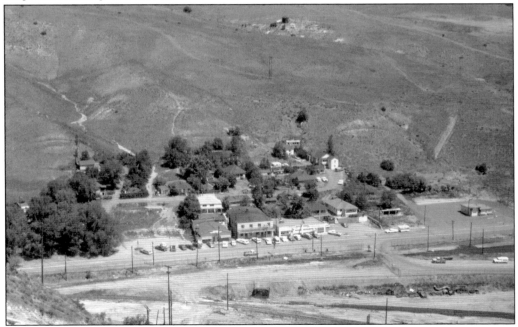

The photograph, taken in June 1970, is looking north across the canyon to Lead Mine. Note how small the town is, how it is laid out, and how the houses are built up on the hillside. For the few businesses that were at Lead Mine, there were a lot of cars, as it was a popular place. Lead Mine is totally empty now; from here on up, the canyon is buried.

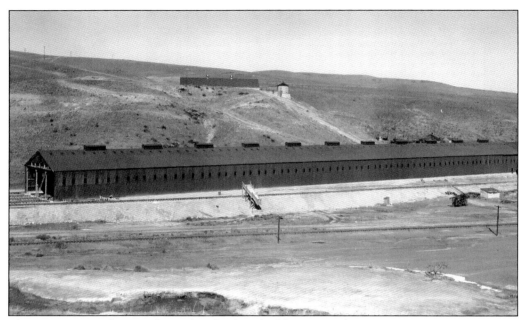

The precipitation plant was housed in this long building. According to *The Guinness Book of World Records*, it was the longest in the world when it was first built in 1929 at 1,520 feet long. The photograph is so long, it had to be divided into two photographs. Early miners discovered that by putting iron into the copper-enriched water, over time, the iron will change to copper in a process known as leaching.

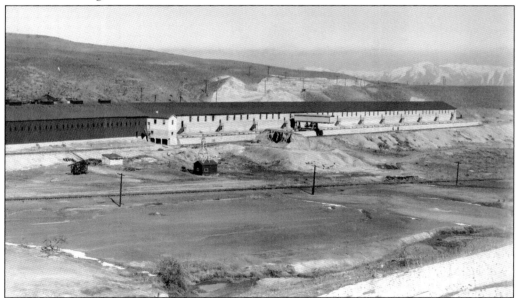

The second half of the precipitation plant building is pictured above. The waste rock all around the mine had small amounts of copper in it. The green water coming out from under the mine dumps was high in copper sulfates. At the precipitation plant, shredded steel (mostly tin cans) and copper-enriched water were placed into vats; over time, a chemical reaction consumes the steel and removes the copper molecules from the water, making copper.

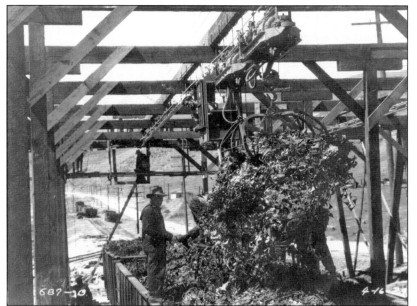

This image shows an overhead crane with a claw picking up scrap metal out of a gondola train car. The overhead crane with the metal-filled claw then traveled to the inside of the long building to unload. Once inside the long building, men would place the scrap metal into vats. Note the silhouette of the man running the crane, center left.

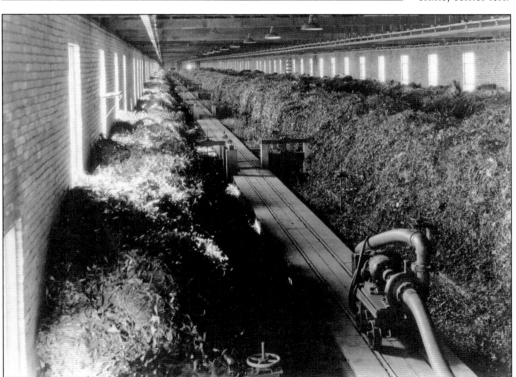

Inside the 1,520-foot-long building at the precipitation plant were leaching vats, which were four feet wide and four feet deep. The vats or launders were filled with scrap metal, and then copper-enriched water filled the troughs; over time, it settles to the bottom, becoming 75 to 90 percent copper. Employees who worked at the precipitation plant said it turned their skin, hair, and clothes, even their underwear, green.

This August 1965 image shows all that remains of the once long precipitation plant building, right. In February 1963, a large gust of wind destroyed most of the precipitation plant's long building. With the building gone, it was easier to move the scrap metal around with fork-lifting equipment and mobile cranes. The old way of overhead cranes in the building was limiting their movement. The new method was more efficient and less expensive.

This 1967 photograph shows the remodeled precipitation plant. Over time, the leaching process was perfected. A new type of cone precipitator was developed at the Kennecott Research Center. Cone-type precipitators were fed scrap steel with a conveyor. Note the town of Copperton above it and the Copperton train yard as it wraps around the town in the top right of the image.

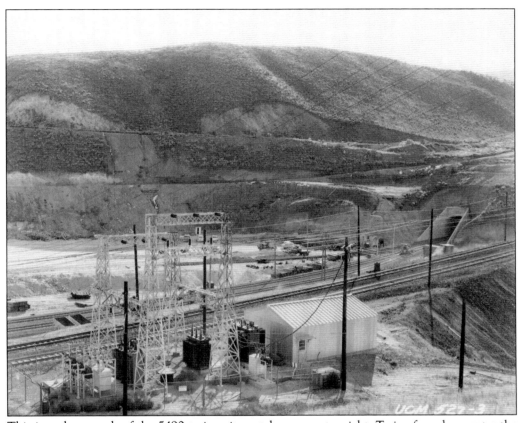

This is a photograph of the 5490 train exit portal, seen center right. Trains from here enter the Copperton yard. The 5490 train tunnel was the last of three train tunnels built in the mine, and their sole purpose was to keep the ore trains moving downhill. In March 1985, a new conveyor system took over the tunnel. In 2022, the conveyor system was moved out of the tunnel to a new location outside of the pit.

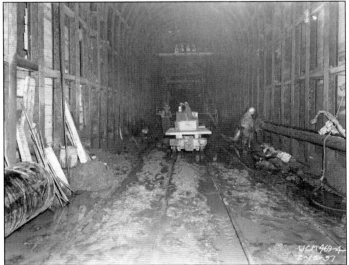

Construction of the 5490 train tunnel is seen here on February 15, 1957. Construction started on the 5490 train tunnel on October 30, 1956. The tunnel was just over 18,000 feet long, it was 24 feet tall and 18 feet wide, and it cost $12 million to build. The first ore train traveled through the tunnel on May 7, 1961. The "5490" name came from the level elevation in the mine.

26

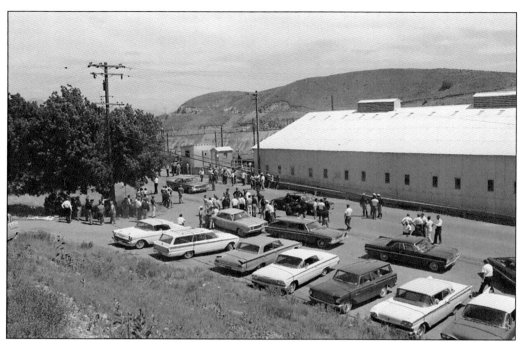

This image shows the July 1, 1964, strike picket line at Lead Mine. The strike went on for two-and-one-half months. Early Utah Copper did not recognize the unions. Daniel Jackling, president of Utah Copper, did not let the unions be organized; he was a hard-liner when it came to unions. It was not until after Jackling retired in 1942 that things changed. (Courtesy of Utah State Historical Society.)

Foremen are working at the precipitation plant; they could keep this portion of the operation going. The first union organized at Bingham was International Mine & Mills in 1944. By 1963, the Utah Copper Division had to deal with 19 separate bargaining units for 7,500 employees. With the unions came strikes, and Kennecott had its share of them over the years. (Courtesy of Utah State Historical Society.)

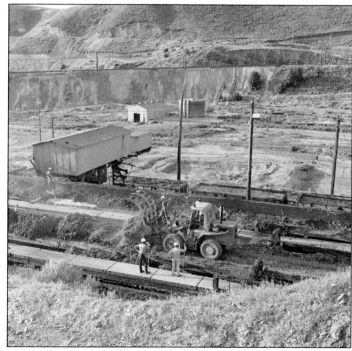

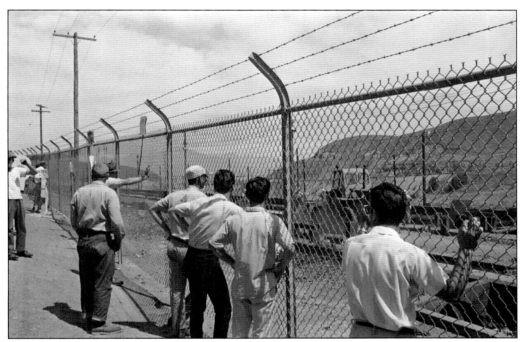

Strikers heckle the foreman trying to work. At strikes and picket lines, the atmosphere was usually light. Sometimes there were arguments and fights but not many. There was typically a police presence to keep the traffic moving and things under control. No matter how long or hard the strike was, the foreman and employees still had to work together when it was over. (Courtesy of Utah State Historical Society.)

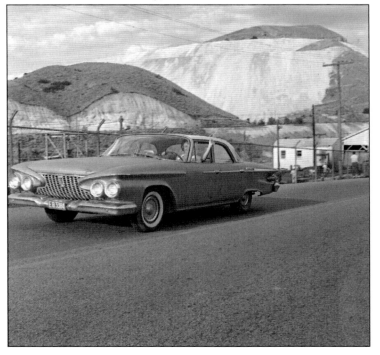

This image shows Stella Saltas driving through the strikers in her 1961 Plymouth Belvedere. She lived in Lead Mine, and her husband was a foreman in the drill and blast department. Just by her look and wave, the situation is not that serious; strikes were hard but mine management and strikers were respectful to each other. (Courtesy of Utah State Historical Society and Stella Saltas.)

This photograph taken on April 27, 1973, shows a ceremony to dedicate a monument remembering Bingham Canyon. On November 22, 1971, the last 31 people of Bingham proposed to disincorporate. Thirty-one people were a far cry from the 15,000 that once lived in this roaring mining town; it was only 67 years old. The city council made several provisions for the town's last rites. One was a three-by-four-foot copper-bronze plaque.

In front of the fire truck is a large 20-ton boulder from the mine, with the plaque affixed to it. The plaque contains highlights and statistics of Bingham Canyon. The boulder was donated, delivered, and set in place by Kennecott. (The crane's cable broke trying to set it in place.) The boulder was ore, so a chain-link fence was placed around it so the people would stop chipping it away.

This image shows the No. 768 electric locomotive heading to the mine or Copperton yard. The "four percent" was the railroad line nickname because of its four-percent grade that came down from Central yard. Looking across the canyon to Lead Mine, this image shows how small this community was. The August 1965 photograph provides just a glimpse of the once long building of the precipitation plant, pictured center right.

This view is looking in the opposite direction over the top of Lead Mine. The precipitation plant building is shown in the bottom right. The precipitation plant became uneconomical; it transformed from being a metal recovery system to a water management system. The active pumping of leach water onto the dumps stopped. The precipitation plant closed in the fall of 2000. Now nothing is left. Note the town of Copperton on the bluff, center left.

Three

DRY FORK

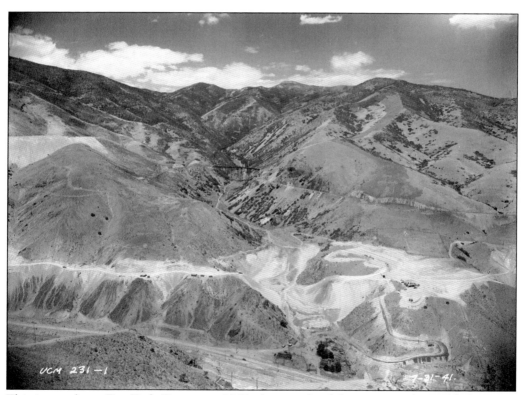

This image shows Dry Fork Canyon in 1941; the mouth of the canyon is being filled in. Dry Fork Canyon branched off Bingham's main canyon to the north. Early history said that Bingham Canyon was named after two brothers, Thomas and Sanford Bingham, sent there by Brigham Young to graze horses and cattle belonging to him. The Bingham brothers moved away but the name remained.

The Dry Fork train shops in 1969 were on the east side of Dry Fork Canyon. Dry Fork Canyon's history involves the Copperton test mill; the Bingham & Garfield Railroad line to the mills, with its large Dry Fork Bridge; the English dairy and the Dry Fork Cemetery; placer mining; and the new train shop, built in the late 1940s.

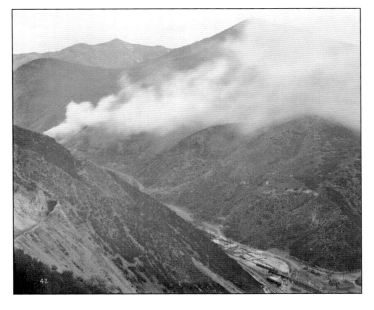

This view is looking down on Dry Fork Canyon, in the bottom right, in 1906. Placer gold, or gold found in a secondary deposit washed down from the original load, was mined at Dry Fork Canyon. Placer mining used panning and hydraulic mining techniques. The West Mountain Placer Mining Company dug a 150-foot shaft up Dry Fork to supply water for hydraulic mining. All around Dry Fork Canyon were placer claims, such as the Curtis placer, Scoville placer, and Days placer.

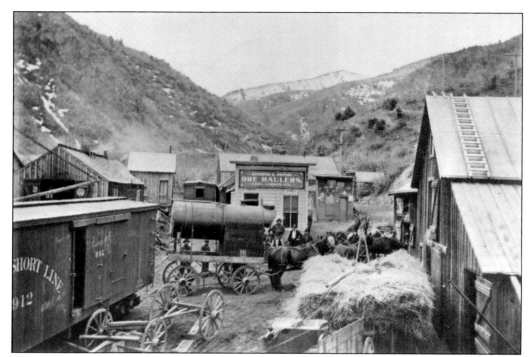

This image shows ore haulers and a horse-drawn water wagon, center. Bingham's early mining days required many horses and mules; early history says that, at one time, there were over 1,000 horses and mules in the canyon. Horses and mules were used in the mines and on rail tram lines. With the train only going as far as Frog Town, transportation from here was usually by horsepower.

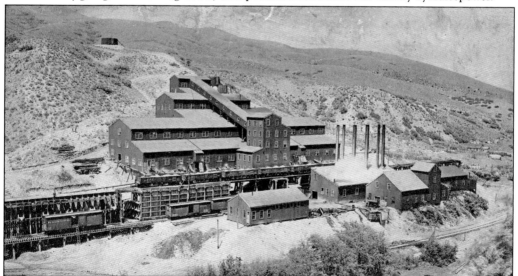

The Copperton test mill, at the corner of Dry Fork and Bingham, tested the feasibility to see if the low-grade ore could produce copper for a profit. The Copperton Mill started production in 1903, producing 300 tons of concentrate a day. By the time it closed in August 1910, it was producing 1,000 tons a day. The water was supplied from the West Mountain Placer Mining Company by a 150-foot shaft.

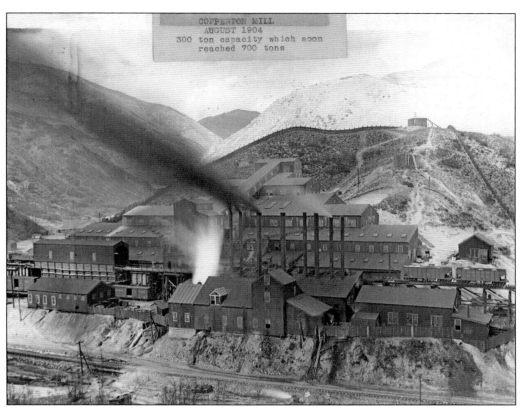

The Copperton test mill is pictured here in August 1904. The Copper Belt Railroad supplied the ore from Utah Copper's underground mine. Utah Copper was incorporated on June 4, 1903; it involves the history of young mining engineers Daniel Jackling and Robert Gemmell, property owner Enos Wall, investors, and a mountain of low-grade ore. It was Jackling's idea to mass-produce copper from this low-grade ore using steam shovels and trains.

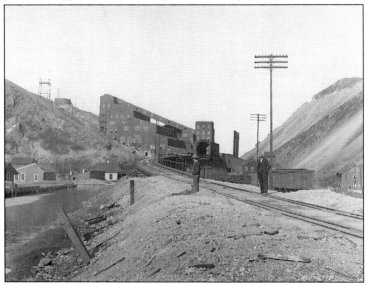

The Copperton Mill was a test mill; two larger mills were built at Magna, at the north end of the Oquirrhs, as there was more room for tailings and a better water supply. The photograph shows a settling pond, bottom left. It had to be built to get more water, as the 150-foot shaft up Dry Fork was not adequate. The Copperton Mill served as a training school for operating the larger mills.

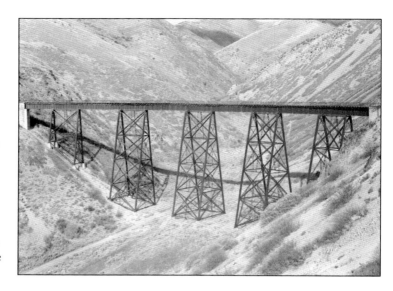

This image shows the Dry Fork Bridge, which was part of the Bingham & Garfield Railroad. Utah Copper built its own railroad line in 1911 after the Rio Grande Western Railroad could not keep up with the volume of ore coming out of the mine. The Bingham & Garfield Railroad came up the north side of Bingham Canyon, and the Dry Fork Bridge was the first large viaduct the trains crossed.

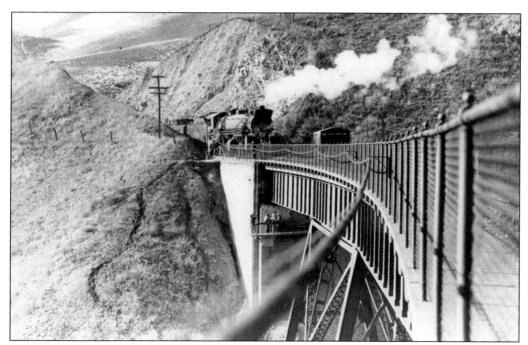

Pictured is a close-up of the Dry Fork Bridge, featuring a train stopping with smoke coming out of the steam engine and men doing repairs on the bridge. When building the bridge, the construction engineers had a hard time finding solid rock at the bottom of the canyon. The solution was to dig down 30 to 70 feet to reach solid rock and then dig a nine-foot-square hole, filling it with solid concrete for the bridge supports.

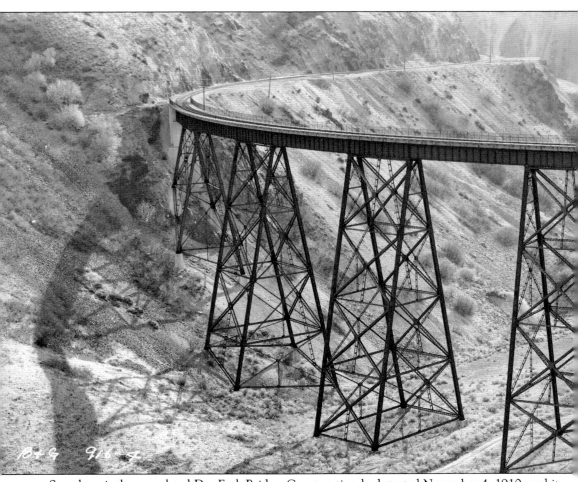

Seen here is the completed Dry Fork Bridge. Construction had started November 4, 1910, and it was 670 feet long and 180 feet high. After crossing the bridge, the trains enter four tunnels and cross two more bridges before entering Utah Copper's open-cut mine. The mine's first ore was transported to the new Magna mill by the Rio Grande Western low-grade line, built from 1906

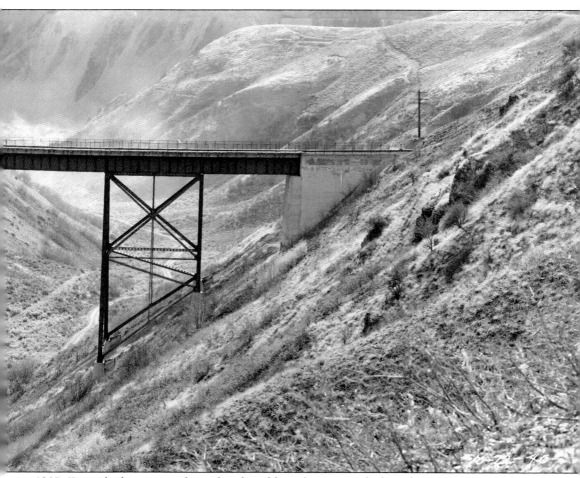

to 1907. From the beginning, this railroad could not keep up with the volume of material being dug with the large steam shovels at the mine. Rio Grande Western refused to make improvements. Utah Copper built its own new railroad line to the mills: the Bingham & Garfield Railroad (1911–1948). Up Dry Fork Canyon, Utah Copper built the first of three large bridges.

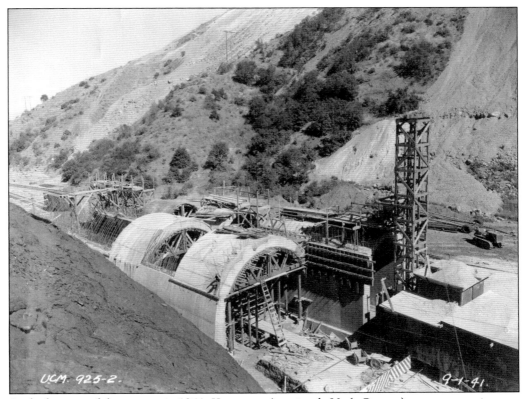

At the bottom of the canyon in 1941, Kennecott (previously Utah Copper) was constructing two tunnels, one for trains and another for vehicles. As the open-pit mine got deeper, Kennecott built a series of three train tunnels in the mine. Trains went through the tunnels, down the south side of the canyon, then crossed over these two new tunnels at the bottom of the canyon to meet up with the Bingham & Garfield Railroad.

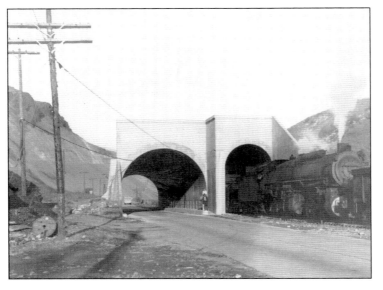

The photograph shows the completed tunnels before the space around them was filled in. This is called the cross-canyon connection. The train crossing through the new tunnel heads to Frog Town. This is a Denver & Rio Grande Western train; it came up from the valley and made two trips a day. Note the two men; one stands while the other is sitting on the railing, in the center.

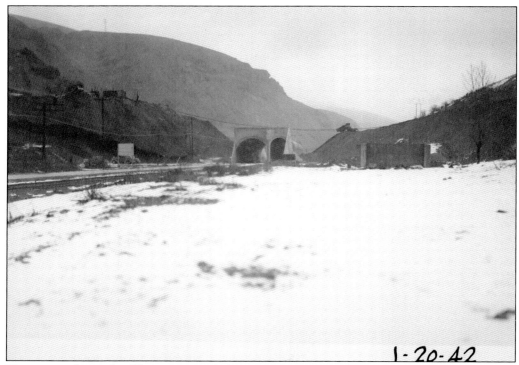

This image shows the filling in around the cross-canyon tunnels on January 20, 1942. A new railroad roadbed had to be built down the north side of Bingham Canyon, and the mouth of Dry Fork Canyon had to be filled in with waste rock. This new cross-canyon line was lower than the old Bingham & Garfield line. The two railroad lines met up farther down the canyon.

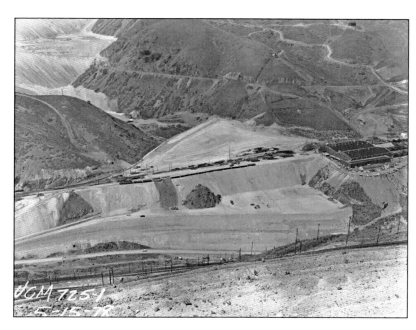

This May 15, 1978, photograph of Dry Fork Canyon shows that most of it is filled in with waste rock. The Dry Fork train shop is center right; it was built in the late 1940s. Above the Dry Fork train shop is the Dry Fork Cemetery. Looking up from the road at the bottom of the canyon, there are no signs that there once was a canyon here.

39

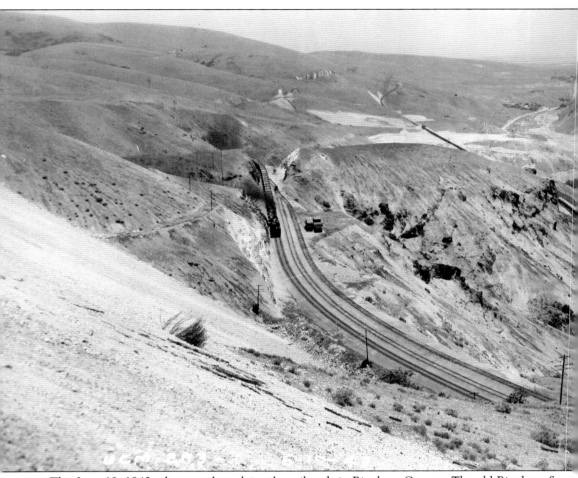

This June 19, 1943, photograph explains the railroads in Bingham Canyon. The old Bingham & Garfield Railroad with the triple tracks is at left. Note the large steam locomotive pulling empty ore cars back to the mine. The new cross-canyon connection is running through the center of the photograph. Note the long string of loaded ores cars making their way to the mills. On the south

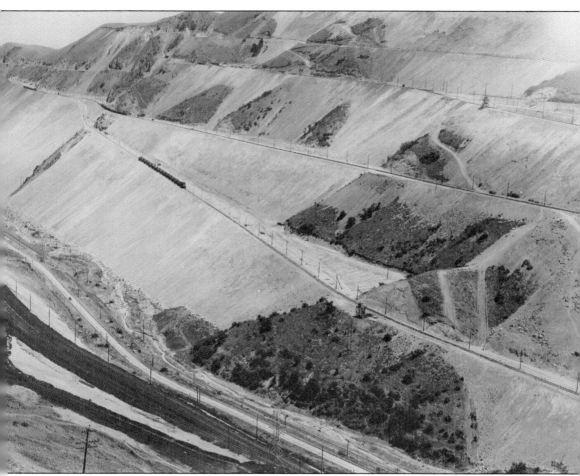

side of Bingham Canyon, there are several switchbacks running down the mountain, to the right. Note the ore trains working their way down the switchbacks; they are heading for the tunnels on the cross-canyon connection. Following the canyon down, one can see the little community of Lead Mine and above it is Copperton.

This image shows the Dry Fork Cemetery, and in the middle is the Chandler tomb. Chandler was an early prominent Bingham family. George Chandler and brother Eugene owned the largest livery stable in Bingham. It later became the Princes Theatre. George owned a mansion in Frog Town. In 2006, Kennecott moved most of the graves to the Bingham Cemetery, just outside of Copperton.

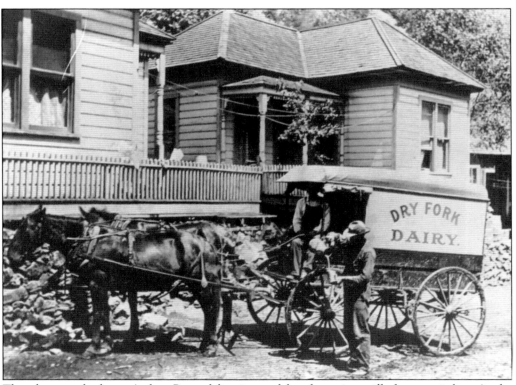

The photograph shows Arthur Parry delivering and hand-pouring milk from a pitcher. At the mouth of Dry Fork Canyon, after the Copperton Mill was dismantled and before the entrance was filled in, there was the English dairy. Harley "Huck" English started in the dairy business in 1920. He started delivering during the early morning up Bingham from his pickup truck and back down the canyon, stopping at each café to pick up scraps for his pigs.

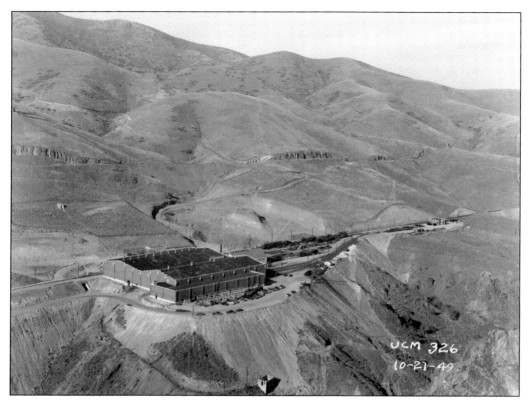

This image shows the completed Dry Fork train shop, also called the "New Shops." The new cross-canyon railroad line route went along the side of the building. The Bingham & Garfield Railroad line is running through the top center of the photograph. Note the old foundations of the Copperton Mill, center bottom, and the Dry Fork Cemetery, center left.

This is a photograph of the inside construction of the Dry Fork shops. Contractors are getting ready to pour the cement floor. Note the railroad tracks down the middle used to bring electric locomotives and waste and ore cars into the shop. Kennecott Copper employees did all their own work on the large roster of electric locomotives at the mine. The lines in the floor are pipes for steam radiant heating in the shop.

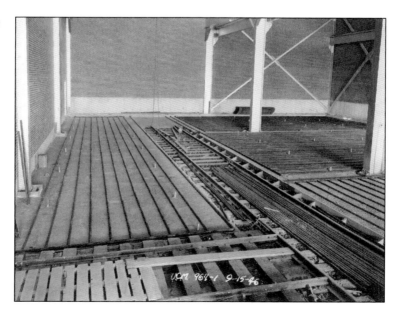

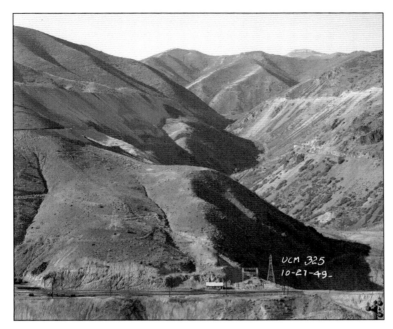

This image is looking up Dry Fork Canyon on October 27, 1949; the Dry Fork Bridge is gone. It became obsolete after building the cross-canyon connection in 1942. Then this route became outdated in 1948 with the building of the new Copperton low line to the mills. Dry Fork Canyon is starting to be filled with waste rock from the D-dump line, as seen in the top left.

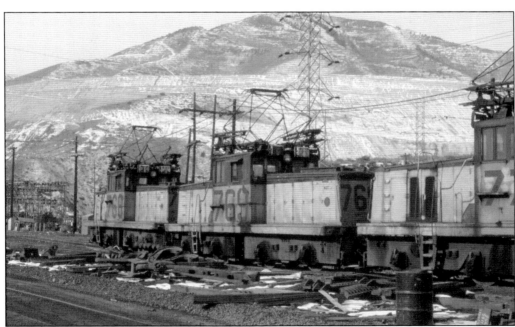

Shown here is the old electric locomotive bone yard at Dry Fork Canyon. The pit electric motors were replaced by diesel locomotives in the late 1970s. The electric railroad at the mine was the largest private electric railroad in the world from the 1920s to the 1970s. Dry Fork Canyon was the city's dump. The Dry Fork shops closed in 1999, and Dry Fork Canyon is now buried as high as the dump line, seen at the top.

Four
FROG TOWN

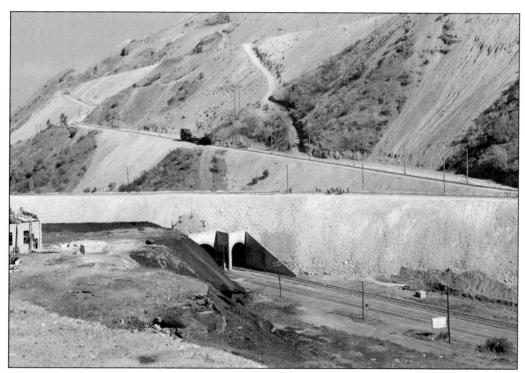

The cross-canyon tunnels are the entrance into Frog Town. This October 2, 1942, image shows the new fill around the tunnels and the track gang laying rail across the top. From here on up, Bingham Canyon would be populated. Note the old slag dump from the Yampa smelter in the bottom left. A line car works on the trolley lines the electric locomotives used for their 750 DC volt power, seen center left.

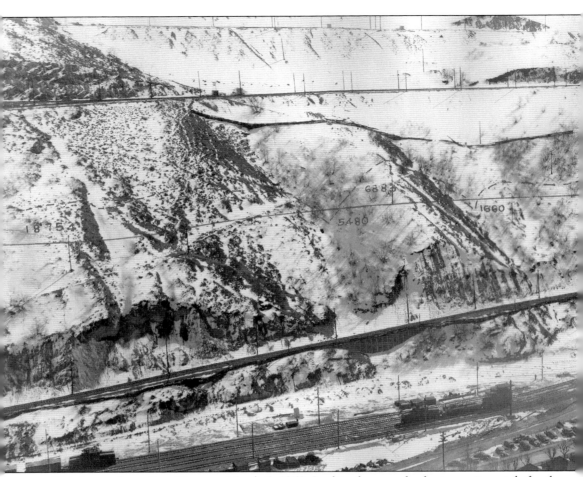

This image shows Frog Town on March 5, 1953. In this photograph, the two exit portals for the train tunnels that came out of the mine can be seen in the top right and bottom center. Houses line the canyon floor; it also had a few businesses: Amicone Bar, Panos Apartments, the Tom Praggastis store, Liberty Bell Bakery, a pool hall, and Dimitri Bakery. This part of the canyon was the widest, and it had two streets, Main Street and Railroad Avenue. These large panoramic pictures were

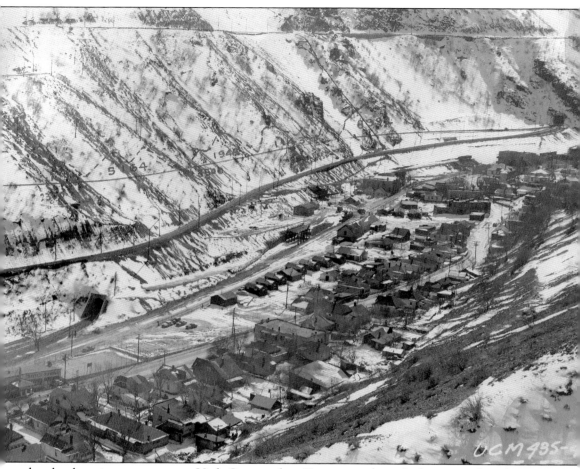

taken by the mine management. Utah Copper, then Kennecott, always had a reason for taking a photograph; some were property assessment, progress of the mine's expansion or construction projects, or to map out different routes, tunnel, or bridge locations. The lines running through the center of the photograph show a new proposed rail route.

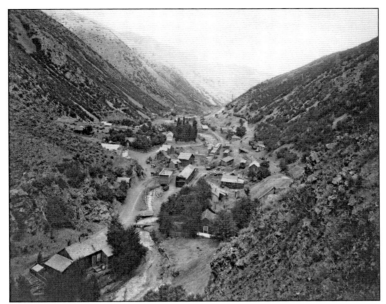

This is an early photograph of Frog Town. French Canadians settled here and ran a sawmill. Logs were brought down from the higher canyons to the sawmill. Upper Bingham had a grove of large trees (Douglas fir), which was used to build the roof of the famous Salt Lake Tabernacle. This photograph shows how wide the canyon is at this location. Note Bingham Creek running down the center of town.

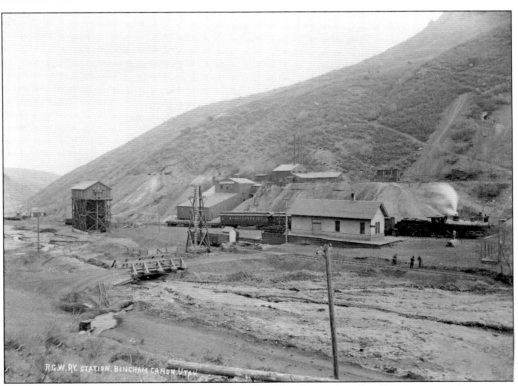

The train station at Frog Town is seen center right. The first railroad to Bingham was the narrow-gauge Bingham Canyon & Camp Floyd Railroad in 1873. The railroad stopped at Frog Town, going no higher. The Winnamuck Mine and mill are just above it. In 1881, the Denver & Rio Grande Western Railway purchased the property, and in 1890, the rail was upgraded to standard gauge. Note the large aerial tram building at center left.

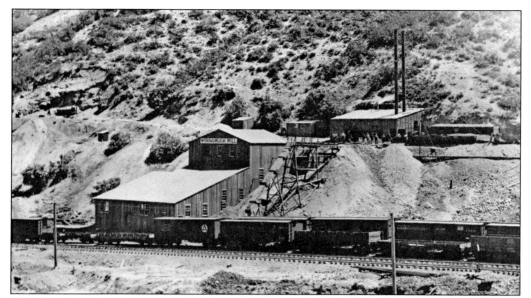

The Winnamuck Mine was an early claim in 1866, and it was built with a combination mill and smelter at the mine site. The smelter was one of the first smelters in the territory in 1871, but it only lasted until 1875. The mill was leased from 1904 until 1907 to the Ohio Copper Company, which used it as an experimental mill.

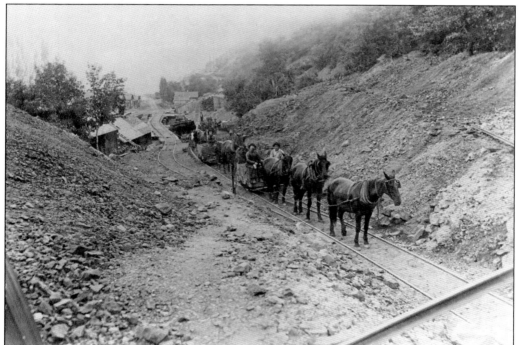

This image shows an early 24-inch gauge rail tramway. The trains from the valley stopped at Frog Town. The early mines had to bring their ore down to Frog Town, first by horse and wagon, which was not easy considering the steep terrain. The loaded ore cars traveled down a four-percent grade by gravity, then horse and mule teams would pull the empty ore cars back up to the mines.

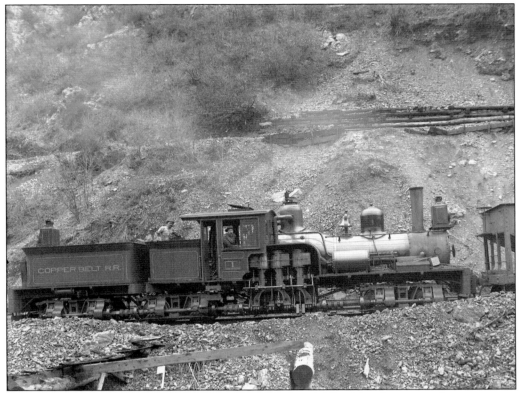

A Shay steam locomotive is on the Copper Belt Railroad. The 24-inch gauge rail tramway was widened, and the route was extended to the mines up Carr Fork Canyon. It became the Copper Belt Railroad in February 1901. Shay locomotives were used on the new route because of its steep grades and sharp curves. The clanking gear-driven Shays were powerful but slow—a man could walk faster.

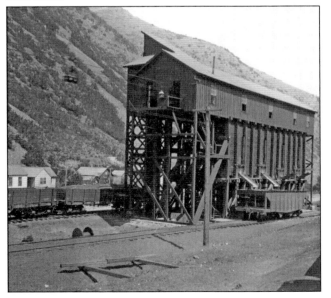

The large Highland Boy Mine's aerial tram building is pictured here. Another way to get ore down to Frog Town from the mines was to use the newly invented aerial tram. Aerial tram lines had ore buckets attached; they were hand-loaded at the mine, and then they made the trip down to their bottom terminal building (with a capacity of 60 tons per hour). They were dumped into waiting ore train cars and then taken to the valley's smelters.

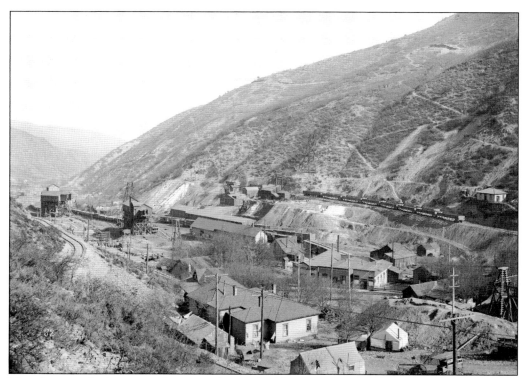

The photograph shows two large aerial tram buildings, seen center left. The first aerial tram building was the bottom terminal for the Highland Boy Mine from 1897 to 1910. The tram line was 4,600 feet in length, and it had a 1,200-foot vertical drop to Frog Town. The second aerial tram building was the bottom of the terminal for the Old Jordan and Galena Mines from 1902 to 1914. Its tram line was three miles long.

This image shows the Yampa smelter at Frog Town. The smelter serviced the Yampa Mine up Carr Fork Canyon. Ores were delivered to the Yampa smelter by the Copper Belt Railroad. The Denver & Rio Grande Railroad purchased the Copper Belt Railroad in 1905. In 1908, the Yampa smelter built an aerial tram from the Yampa Mine and that traveled right into the smelter.

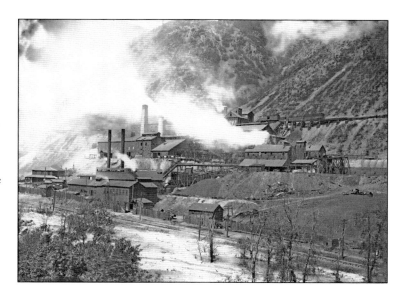

51

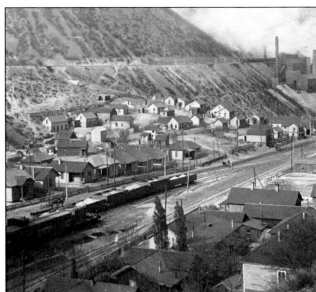

The Yampa smelter was built in 1904. There were a few businesses and houses next to the smelter, as seen to the left. The smelter was only around for six years, until 1910. Some of the reasons why it closed were because the Yampa Mine could not supply enough ore to run the smelter at full capacity and that it was cheaper to haul the ore down to the valley smelters than to haul coal, coke, and flux up the canyon.

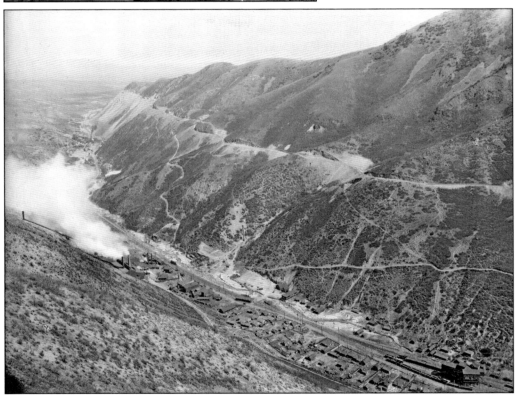

This image is looking down on the smoky Yampa smelter, center left. The smoke in the canyon was a problem. The Yampa smelter tried to remedy it by building a long flue up the mountainside, then into a smokestack, center left. This photograph was taken in 1907. Note the houses on the canyon floor and the large United States Mines Company aerial tram building in the bottom right. The Yampa smelter closed in 1910.

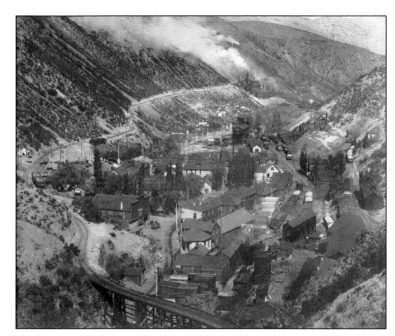

The photograph shows a trestle crossing Bingham Canyon; it was part of the Copper Belt Railroad spur line to the Yampa smelter, seen bottom center. The Copper Belt Railroad, owned by the Denver & Rio Grande, delivered ore from the Yampa Mine to the Yampa smelter. The trestle was built in 1903 and was removed in April 1915, after Salt Lake County condemned it. The area above the trestle would be considered the beginning of Bingham.

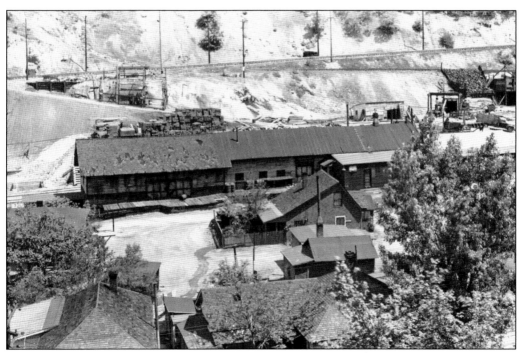

The Denver & Rio Grande Western depot at Frog Town is pictured on June 9, 1951. Trains up from the valleys stopped at Frog Town, going no higher. The first train depot at Frog Town was a narrow-gauge boxcar ticket and express office. A small portion of property was purchased in Frog Town, and then on June 25, 1896, a new depot was built. Over time, it was enlarged to its present size.

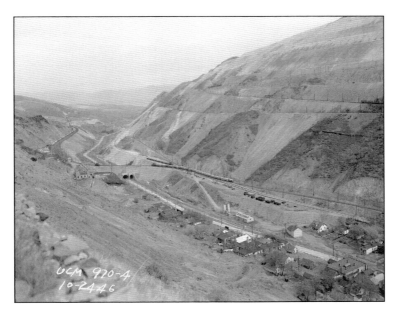

This image is looking down on Frog Town, facing northeast. Note the two tunnels of the cross-canyon connection; this is the beginning of Frog Town. Next to those entrance tunnels is the old slag dump of the Yampa smelter, center left. The loaded ore train crossing over the tunnels is heading for the Central yard, where large trains are made up for the trip to the mills.

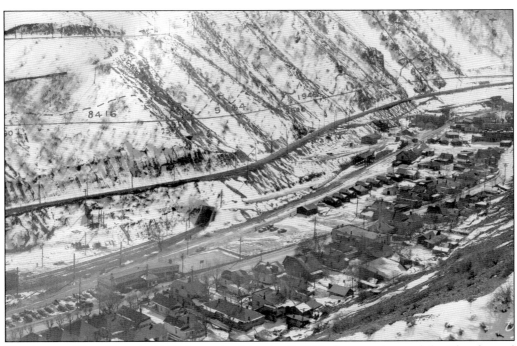

This image of Frog Town in 1953 shows the Adderley & Nichols gas station and the Chrysler and Plymouth dealership, seen bottom left, with the tennis court–playground next to the gas station and the 5840 train tunnel exit portal above it. Railroad Avenue, behind the gas station, runs up to the Denver & Rio Grande Western depot. The Alexander Apartments are pictured at top right. North across Main Street was Christ Apostols Grocery, with Furgis Apartments above it.

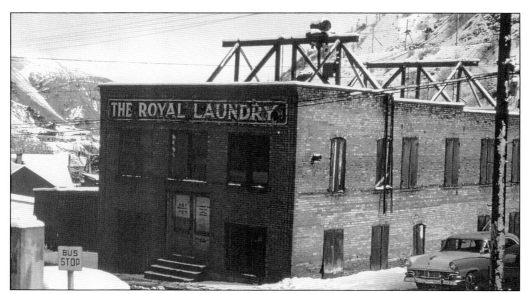

Seen here is the old Royal Laundry building in Frog Town. It was the only commercial laundry in the canyon, and it closed in 1934. The 2,408-square-foot building stayed around for a long time, and it was purchased by Kennecott in 1971. At the Royal Laundry, the road splits off to the short Dixon Avenue and Hegland Alley. Hegland Alley met up again with Main Street where the road branched off to Freeman Gulch.

This image is looking down on Frog Town in the 1960s. The George Chandler mansion is now the Cook Apartments, seen bottom left. The Royal Laundry building is on the top right. Main Street branched off just before Fire Station No. 2, up Freeman Gulch. Apparently, the "Freeman Gulch" name came from a tragic event on May 10, 1870, when a landslide killed Charles Freeman and James Leicester, who were sluice mining.

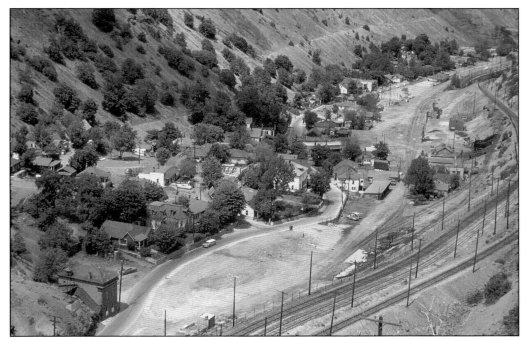

This photograph shows where Frog Town ended before entering Bingham proper. Buildings and houses were being removed, and by the late 1960s, Kennecott was buying as much property as it could. Fire Station No. 2 was built right up against that rock formation, seen bottom left. The stairs in the back of the building went up to the second floor, where there was a pool table and activities took place.

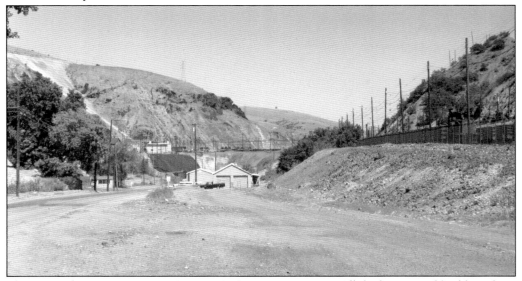

This image shows Frog Town in August 1975. Everyone is gone. All the houses and buildings have been demolished or moved to the city's Dry Fork dump. The cross-canyon tunnels are obstructed from view by the two buildings at center. The Yampa smelter slag dumps are still around, pictured center left. Note the rock formation above the Central yard; it was called "the lion and the mouse" and is seen in the center of the photograph.

Five
MARKHAM GULCH AND SCHOOLS

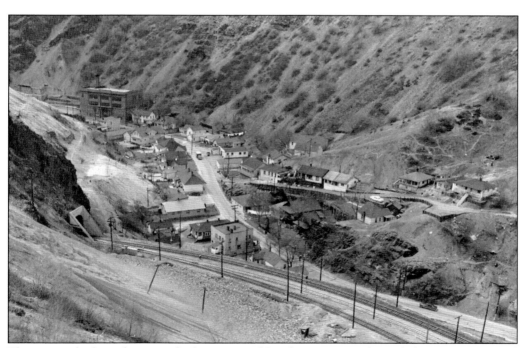

This view is looking down on the beginning of Bingham proper. The rock formation separated Frog Town from Bingham, seen bottom right. The road and houses going up the rock formation are Heaston Heights. The exit portal of the 6040 train tunnel is at left. Houses line the street up to the civic center, once part of the gymnasium shared by the high school and elementary school. In 1935, the American Legion took it over, and it became the civic center.

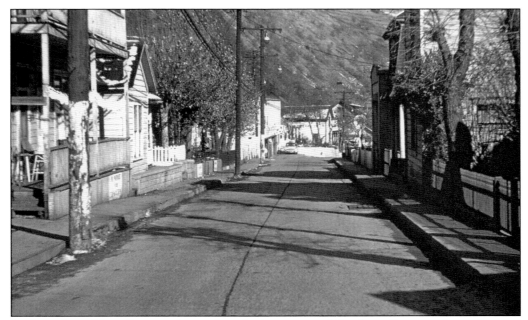

Looking down Main Street is the road to the lower part of Bingham Canyon, where the town started. The houses are crowded along the narrow street. Up from here, the Jordan School District built the high school and grade school, with a gymnasium for both. The schools moved from one side of the canyon to the other and were built next to Markham Gulch.

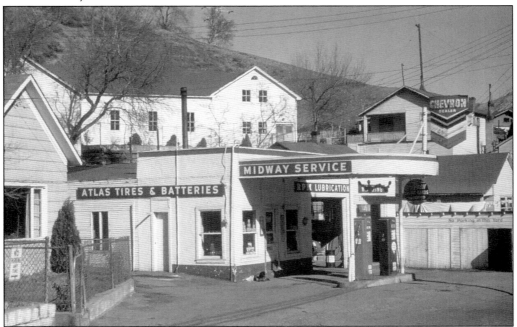

On the road up the canyon was a small gas station, Midway Service; the original owner was Hunt Neilson. He had two friendly, large, black Labrador dogs that hung around outside. On the hillside in the back was the Church of Jesus Christ of Latter-day Saints chapel. The last meeting was held in June 1961.

The first Bingham High School was on the second floor of Canyon Hall, seen center left. The first graduating class in 1912 had five students, who declared "We are only five, but we mean to show our loving parents and our teachers that the hours of toil and worry they have spent trying to instill in us the principles of right living have not been wasted. We leave the school our love and gratitude."

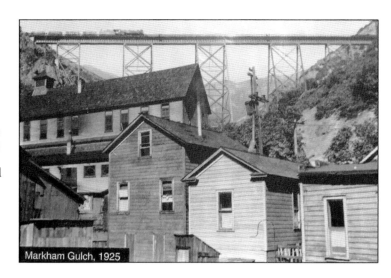

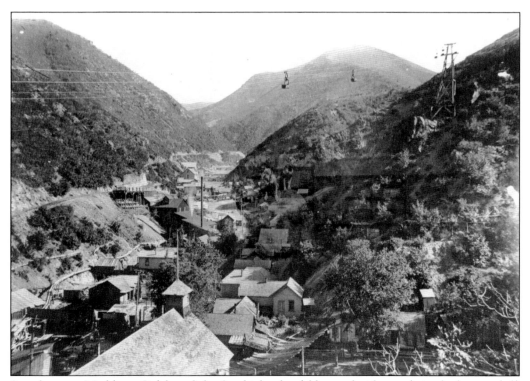

Seen here are Markham Gulch and the first high school (the roof with cupola in the bottom left) in Canyon Hall. Note the aerial tram line with buckets crossing over Markham Gulch, heading for Frog Town. Bingham High School's second location was on the north side of Main Street; construction started in 1910 and was completed in 1912. The school complex consisted of the high school, Bingham Central Grade School, and gymnasium and cost $109,923. The school transported students on horse-drawn buses.

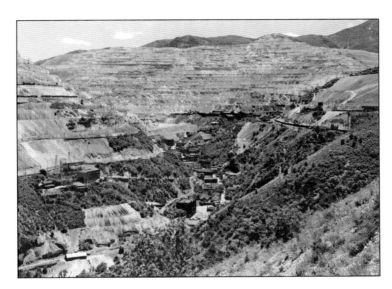

Bingham High School moved across Main Street in 1925, as seen bottom center. It was now on the south side of the canyon, right next to Montana-Bingham mine and dump, from 1925 to 1931. The students called it the "Old Blue Prison" because of its bluish-colored brick. After 1931, Bingham High School moved down to Copperton, and the building became the new Bingham Central Grade School.

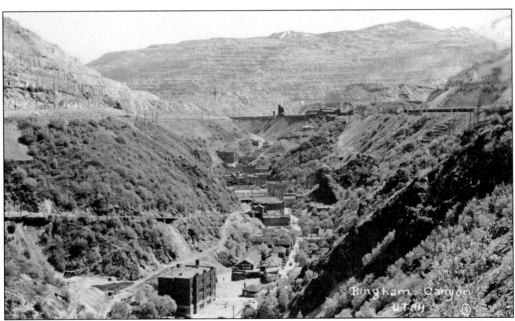

This photograph is looking up Bingham Canyon, with the high school in the bottom left. The early years of Bingham High School were the start of many traditions: the nickname "Miners," the school colors of royal blue and white, and B Day. On April 8, 1927, students constructed a large "B" on the mountainside (facing the valley). Over the years, it was enlarged and whitewashed, and in 2018, lights were added.

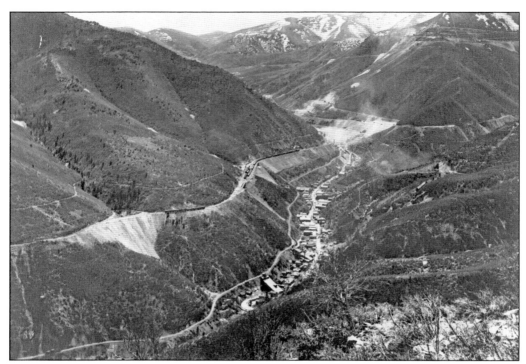

This early view is looking up Bingham Canyon around 1906. Open-cut mining had just started on the mountain, seen top right. Note the large mill building with the slanted roof in the bottom center. Over 40 small mills were built in Bingham Canyon, and they separated the ore from the host rock, first by grinding and then separating minerals, but this process varied from mill to mill. The most common mill techniques were gravity shaking tables or the leaching process.

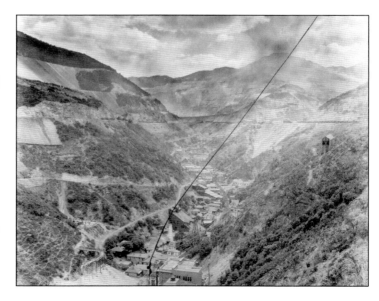

This photograph, dated 1915, is looking up early Bingham Canyon. Bingham High School and Bingham Central Grade School are on the north side of the canyon, seen bottom center. Across the street from the schools is the Montana-Bingham mine and dump. Up the canyon are two large mill buildings; the first is the Red Wing/Markham Mill, and the next one up the canyon is the Dewey/Wall Mill. Mill names changed with different owners.

This March 21, 1908, photograph shows a train wreck on the Copper Belt Railroad that crashed into the Colonel E. Wall (Dewey) Mill. The engineer and fireman were killed. This mill was destroyed several times (the latest time before this incident was in March 1907). The Copper Belt Railroad traveled just above the mill; a man seen top right stands on the railroad's roadbed. The mill was rebuilt after each accident, with the addition of improvements.

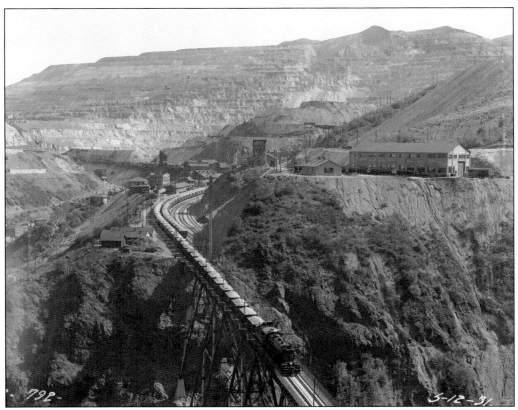

The magnificent Markham Bridge was part of the Bingham & Garfield Railroad. The book *Old Reliable* by Lynn R. Bailey declared it as "one of the most marvelous little roads in the world." Trains of up to 92 cars were made up for the trip to the mills. Heavy Mallet articulated compound locomotives were used for the trip. The Markham Bridge was 640 feet long and 220 feet high, and its construction was completed in June 1911.

A passenger train is crossing over the Markham Bridge on the Bingham & Garfield Railroad. The Bingham & Garfield line was a common carrier. For a short time, from 1911 to 1921, it had passenger service. Many tourists as well as mine officials had their first glimpse of the mine from this railroad. This 16-mile railroad line took 18 months to build and cost $3,336,000.

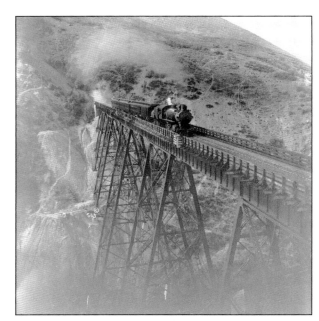

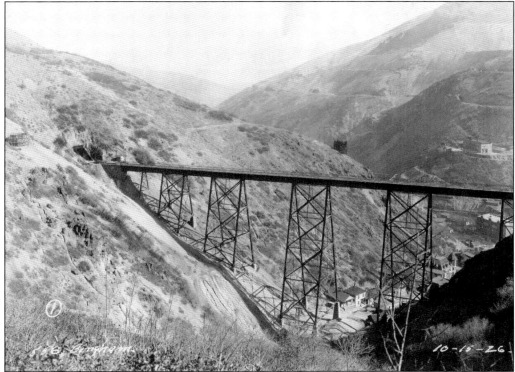

The photograph is looking down Markham Gulch to the Markham Bridge from the other direction. Dated October 15, 1926, the image shows the bottom of the gulch and follows the houses down to the Elmerton Hotel, bottom right. Across Main Street is Bingham High School, center right. Above the high school up on the mountainside is the Utah Power and Light substation, built from 1913 to 1914.

This August 11, 1930, photograph shows the Markham Bridge supports and a house right next to them. Markham Gulch was plagued with floods and mudslides over the years. In 1944, Kent Abplanalp said his mother, sister, and he were in a small room in front of the house they rented high up Markham Gulch when a flood with debris ripped off the front of their house.

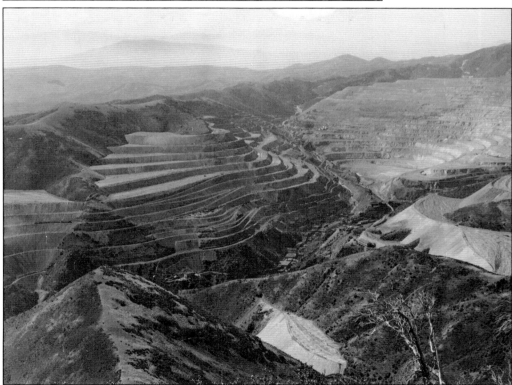

In this view looking down on Bingham Canyon in 1930, the open-pit copper mine is seen top right. The canyons and gulches down Bingham Canyon are being filled with waste rock from the mine, seen bottom center. The Utah Power and Light substation can be seen high on the mountainside above the town, bottom center. The first power line came in, crossing over the Oquirrh Mountains from the Jordan Narrows. The Utah Power and Light substation at Bingham was demolished in 1974.

This 1942 view is looking across Bingham Canyon toward Markham Gulch and its bridge. Markham Gulch is now filled with waste rock. During World War II, the Kennecott Mine produced one-third of the copper used for the war, generating record amounts of ore. The backside of the Utah Power and Light substation is at bottom right. Bingham Central Grade School is pictured bottom center. Looking up Markham Gulch, the Elmerton Hotel can be seen.

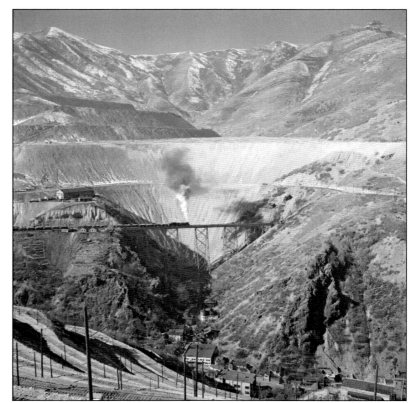

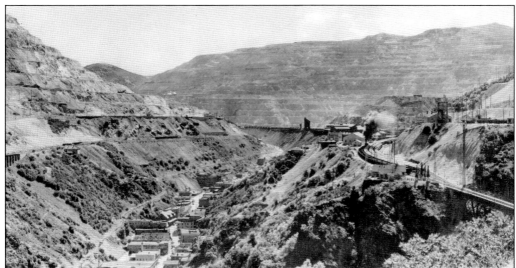

This photograph is of Bingham Canyon in the early 1940s. The mine that was once a mountain is mostly eaten away, and it is starting to make a pit. Trains heading to the mine crossed over Markham Bridge, bottom right. The trains will then cross over Carr Fork Bridge and enter the mine. This railroad line was at an elevation of 6,340; it was named A-level and was the bottom of the mine for many years. Once digging started below A-level, the levels were named with their elevations. Note the town of Bingham running up the center of the photograph.

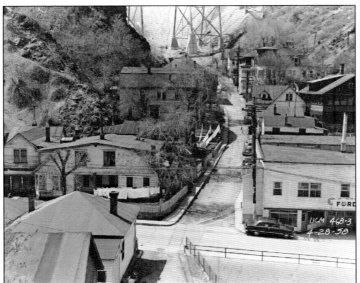

There were a few houses and boardinghouses up Markham Gulch, and the most famous was the Elmerton Hotel, seen top right. Over the years, it changed its appearance many times. The people of Bingham refer to it as the best hotel in town. Musicians and actors stayed here, as it was close to Canyon Hall, where they would perform. An old advertisement stated rooms were $2–3 a day.

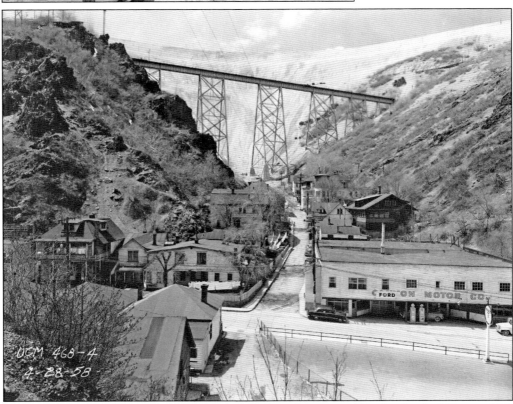

In this image of Markham Gulch, Canyon Hall is on the corner. The first level of Canyon Hall housed Canyon Motor service station; it appears the business was going to begin selling cars as well (note the new Ford sign). Canyon Hall, at the corner of Markham Gulch and Main Street, was the most famous place in town. It was a social center with dances once a week, theatrical programs, and an opera house. The floor could be raised, lowered, or inclined for better viewing with jacks.

This view is looking down on Markham Gulch on June 20, 1960. Houses and buildings were being demolished, and soon, the entire gulch was void of houses. Behind Canyon Hall, a large boardinghouse is being razed, center right. The Elmerton Hotel is above the destruction, hidden by the trees, center right. The houses that were built next to the Markham Bridge's supports are now gone; the area is just a parking lot now.

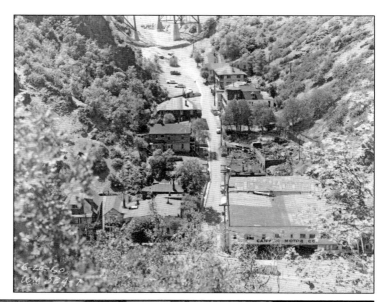

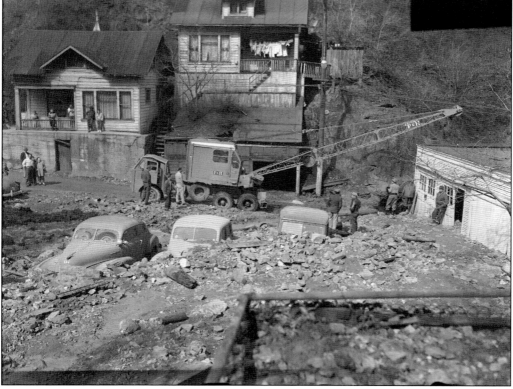

On April 8, 1952, there was a freak flood that started behind Bingham Central Grade School. The old, abandoned Montana-Bingham mine had been boarded off, so water built up and then broke loose. The water rushed down behind Bingham Central Grade School, damaging a few homes and cars and blocking the city's only street. The Jeep Woody (center right) belonged to city councilmen Francis J. Quinn; his home was also damaged. (Courtesy of Utah State Historical Society.)

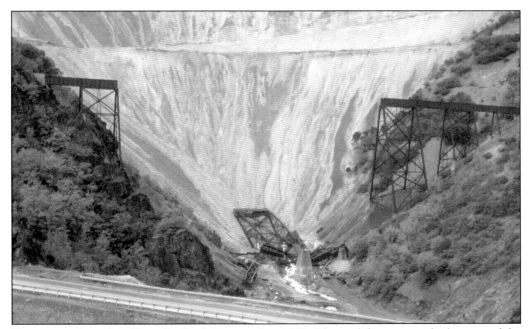

This image shows Markham Bridge being razed in 1981. The mobile crane at the bottom of the gulch gives perspective on how large the bridge was. By 1981, Markham Gulch is void of houses, and all of Bingham Canyon has been razed. Kennecott bought people's property, and as soon as the sale was final, buildings and houses were leveled, giving all who stayed a sense of doom and accelerating the demise of Bingham.

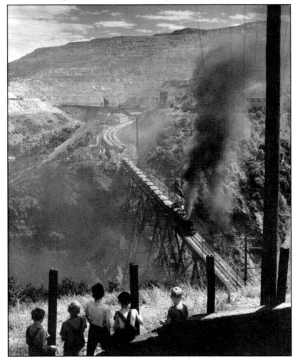

Young boys look down on Markham Bridge. The steam locomotive is backing up to pick up more loaded ore cars for the trip to the mills. The picture tells the story of the kids that grew up in Bingham. This place was their playground, and they explored every notch, gulch, and canyon. There was a certain independence and toughness about the children from Bingham. Most ended up working at the mine.

Six
MAIN STREET

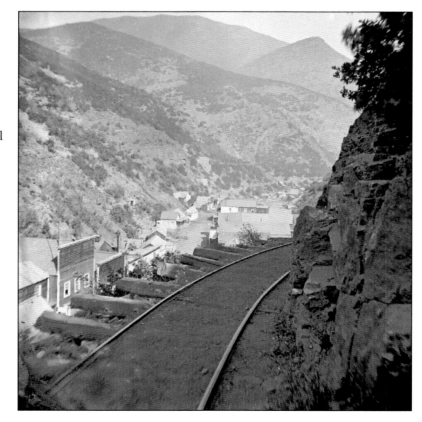

This image shows early Main Street and the narrow-rail tramway at right. The rail tramway would be widened and become the Copper Belt Railroad. How close it was to the town became problematic. This early view of Main Street changed many times over the coming years. As Main Street started to grow, every space was filled with buildings and houses.

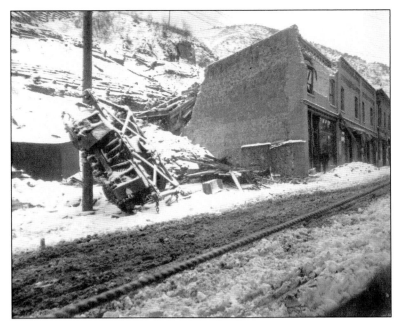

On February 15, 1912, a Shay steam locomotive on the Copper Belt Railroad slipped off the tracks and came crashing down through buildings on Main Street. One story said disgruntled employees greased the rails, making the train slide off the track. All four crew members died, as did two people in the bank building below, and eight others were injured. It is said that Charles Conklin lost his leg.

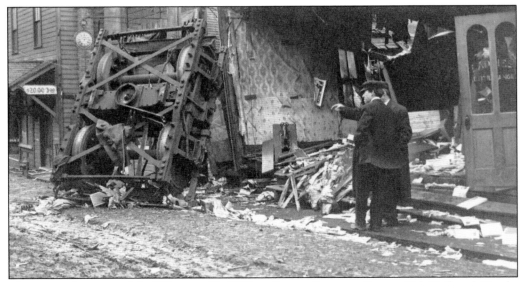

This is another view of the February 15, 1912, train wreck on the Copper Belt Railroad. Trucks of the Shay locomotive came all the way through the building and landed on Main Street. Some of the wooden buildings had to be removed to get the Shay locomotive out. The business the men stand in front of is Eastman Harness and shoe-repair store; boxes of boots and shoes can be seen in the rubble.

Many horses are trying to pull the Shay locomotive boiler down Main Street from the February 15, 1912, wreck. The brick building was hit so hard that it knocked the side out of alignment. Note the sign to the right above the horses, the Golden Rule Store—the early name of J.C. Penney Company. At Bingham, it was one of the first in the chain of stores.

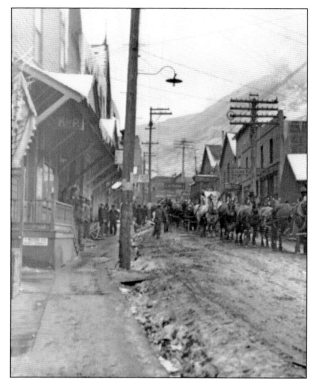

This view is looking up Main Street before 1928, as that is when the road was paved. The Golden Rule Store has changed to the J.C. Penney Company. The building across the street with the roof awning is where the post office moved to for a short time. Bingham's mailman delivered mail on horseback (the route was all uphill); it was the last place in the country to do so.

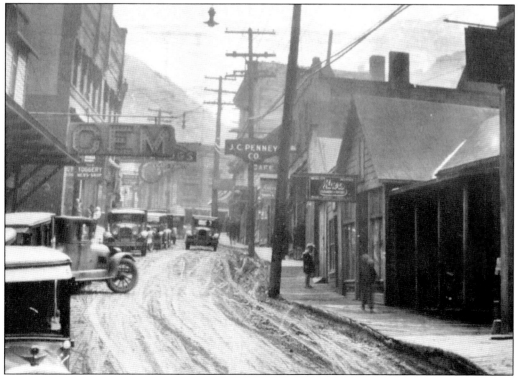

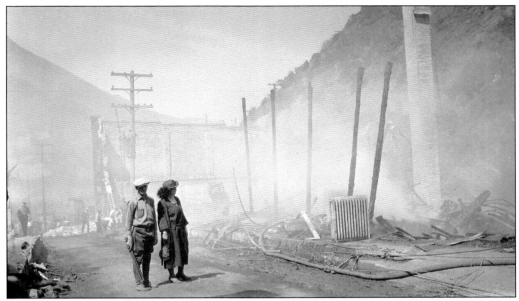

There was a fire on Main Street on August 17, 1924. It started at 1:45 a.m. in the basement of the Bourgard Butcher shop. The suspect was a defective fuse in the electric ammonia refrigeration plant. Destroyed were the Bingham garage, doctor offices and residences, a shoe shop, Union Hall, boardinghouses, and four homes. Two firemen lost their lives, and one was severely burned when the Union Hall roof collapsed. Note the couple's attire.

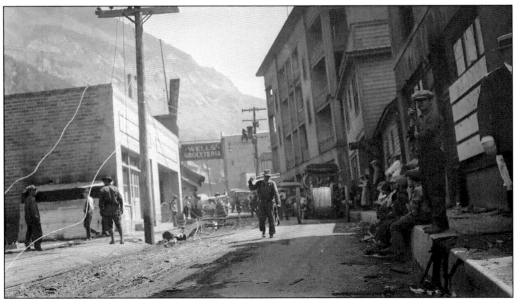

This view is looking up Main Street after the August 1924 fire. The destroyed buildings were made of wood, so they went up in flames instantly. The estimated property loss was $100,000, and many were not insured or were underinsured. A positive note was the area was rebuilt shortly after, this time with brick or cement structures. Note all the people on the street, children sitting and watching workers stringing new power lines, and all the onlookers.

Construction of the new Bingham Canyon Post Office took place in 1933. A large parcel of land from the 1924 fire remained vacant for nine years. The first post office started in 1870, in a building just above the junction of Main Street and Carr Fork. The second post office was on the ground floor of the Golden Rule Store (later the J.C. Penney Company). The third post office was in Social Hall (it had a roof awning) in the 1920s. The last post office was located at 407 Main Street.

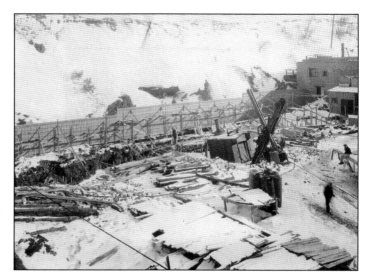

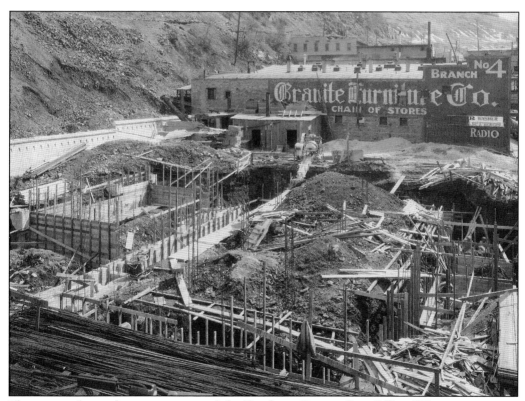

This image shows the construction of the Bingham Canyon Post Office. When constructing buildings in Bingham, the first thing was to erect a large retaining wall along the back, seen at left. This was a must in Bingham due to the steep mountain in the back; rocks were always coming down. The new post office was built on the south side of the canyon. The building next to it was Granite Furniture, the fourth branch in the chain of stores.

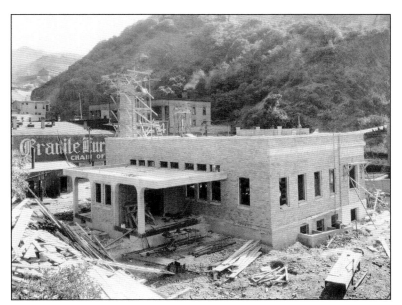

Pictured is the construction of the 1933 post office at 407 Main Street. Men work on the loading dock at the rear of the building and are bricking the chimney. Bingham residents said it was the most handsome building on Main Street. The construction of the post office and the surrounding building are made of brick and cement, a direct result of the 1924 fire on Main Street.

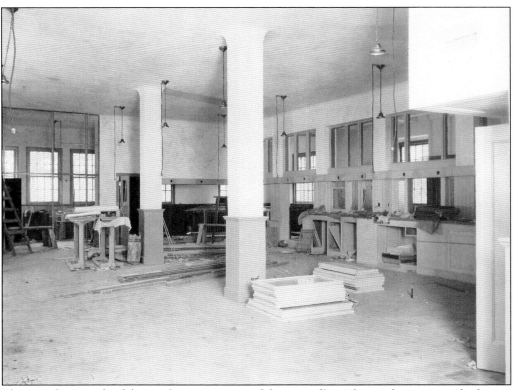

This is a photograph of the inside construction of the post office. The inside is going to look nice, with moldings, cabinets, beadboard around the posts, and the light fixtures. Note the table with the plans; the architects were Scott & Welch, the same firm that planned the community and houses of Copperton. James A. Farley was the postmaster general at the time the building was being constructed.

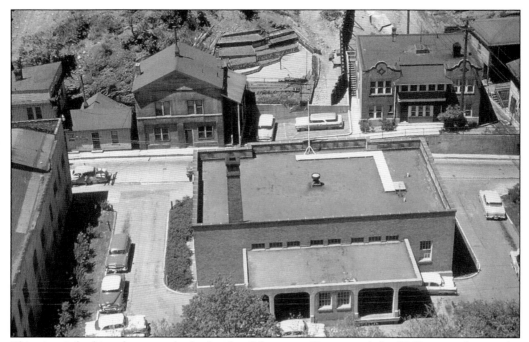

This view is looking down on the back side of the post office around the 1960s, according to the cars. Across the street is the Utah Copper Hospital, top right. The first offices and residences of the doctors were destroyed in the 1924 fire on Main Street, and the new hospital was built shortly after. Some of the first doctors were Russell Frazier, H.C. Jenkins, and dentist B.D. Bennion, who had an upstairs office.

This image is looking down on Main Street and the Utah Copper Hospital, bottom center. Across the street from the hospital is the vacant lot where the post office was built in 1933. High above on the mountain is an ore train of the Bingham & Garfield Railroad, seen up top. It will next cross over the Markham Bridge on its journey to the copper mills.

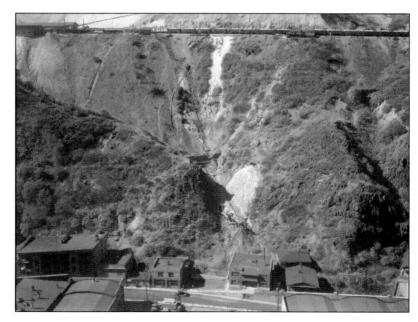

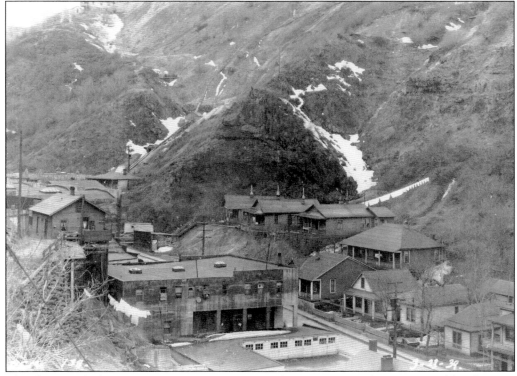

The photograph shows Main Street running up Bingham Canyon. Parking was a problem because of the narrow street. Parking garages were built all along Main Street, as seen at bottom left. Every available space was filled with houses or buildings. Houses were erected in layers up the mountainside, with one behind another. Note the three houses built on the ledge above Main Street.

This image shows another view looking down on Main Street. The Utah Copper Hospital is at bottom left. The large building across Main Street was Cal Huntsman's Standard Garage, bottom center. Some families who lived in the three homes on the ledge were, from left to right, Sluga, Smith, and Lovat's house, bottom right.

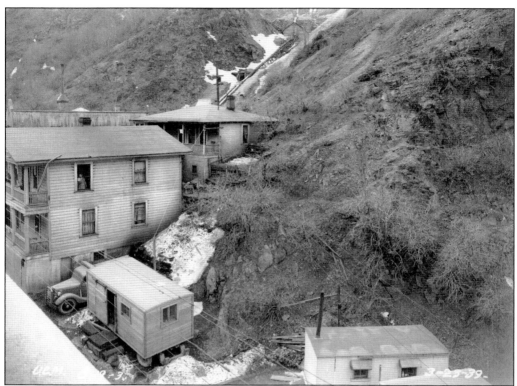

Seen here are the boardinghouse and house next to Utah Copper Hospital. The buildings and houses were constructed right back into the mountain and were stacked on top of each other. One of the benefits of building one's house into the hillside is that a spot could be dug for hiding liquor during Prohibition. The immigrants could not understand how banning alcohol could solve social ills; they thought just the opposite.

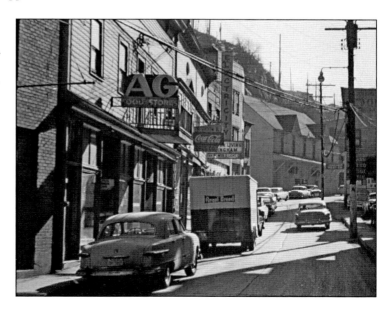

This view is looking up Main Street in the 1950s. Some of the stores and businesses in this section of Main Street included the AG grocery store, the Union Rexall Drug, Utah Power and Light office, Bogan Hardware, Bingham Meat, the Mascot Apartments, Bingham Drug, the *Bingham Bulletin*, Berg's Furniture store, Bingham Radio shop, and Bingham Hospital. Businesses came and went along this strip of Main Street.

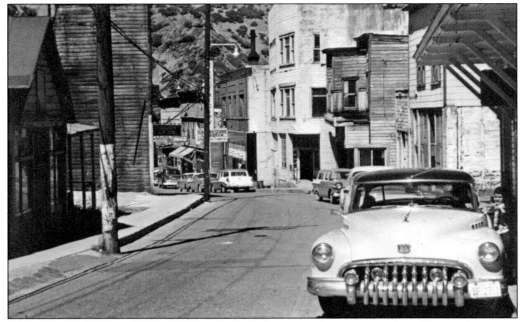

This image is looking down Main Street from the other direction. Bingham Hospital is in the center of the photograph. Dr. Paul S. Richards came to Bingham in 1923 and took over the hospital, which had been started by Dr. Straup. Dr. Richards worked tirelessly with the community helping to improve conditions. He became known as the "father of occupational health" in Utah, as he worked to reduce injuries and fatalities among the miners.

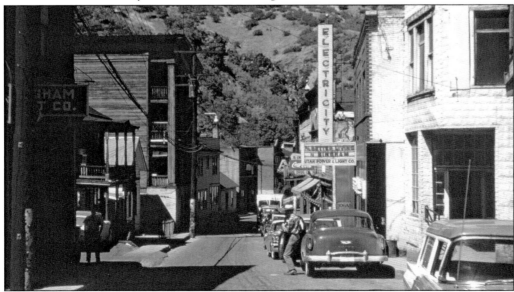

This is a closer view of the Bingham Hospital, seen right. Dr. Paul Richards spent his first days in the hospital cleaning; he focused on the operating room, with soap and brush he purchased at J.C. Penney Company, and cleaned all morning. In less than 48 hours, there was an appendectomy and a pregnancy case that required an operation. Dr. Richards developed new techniques in back surgery that were used worldwide.

Main Street is seen here during the late 1920s. It was paved in 1928 at the time of the economic depression, which eventually settled over the whole world. The people of Bingham watched copper prices, once 24¢, drop to 10¢ a pound by the end of 1930. Production was cut back 65 percent at the mine, and the Utah Copper company scheduled employees a couple of days a week to retain them.

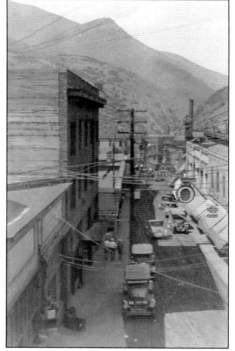

A flood poured down Main Street on April 30, 1925. Living in this high mountain canyon brought many disasters, floods, mudslides, avalanches, and, the worst, fires. In the 1930s, during the Depression, the Works Progress Administration put sewer and storm drains under Main Street. The calamities did not discourage the people of Bingham—they brought them together.

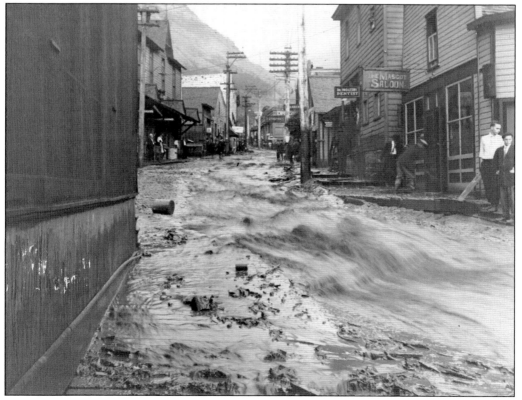

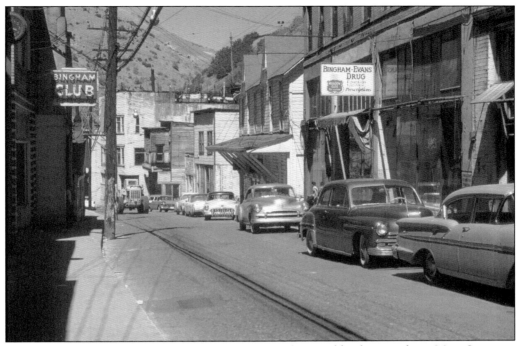

A front-end loader goes down Main Street in the center left of this image. The picture shows that Bingham's days are numbered. The photograph was taken in the early 1960s, according to the cars. It is not good news when a front-end loader goes down the street; it means another structure was demolished. Note all the buildings in disrepair, the tattered awnings, and the littered street, all showing that Bingham is in decline. Bingham was disincorporated on November 22, 1971.

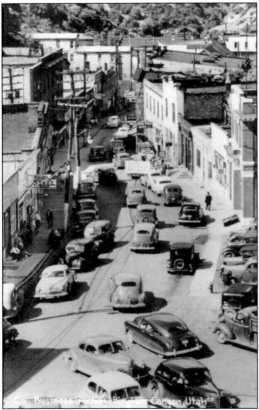

This image is looking down on a busy Main Street from the confluence in the 1940s. According to the 1940 census population reports, Bingham had 2,834; Copperton, 861; Highland Boy, 587; Lark, 515; and Copperfield, 1,134—a total of 5,931. During World War II, the mine produced more copper than ever before. Many men rushed to serve, and women went to work at the mine. Out of the 850 who served, 16 gave their lives.

Seven
THE CONFLUENCE

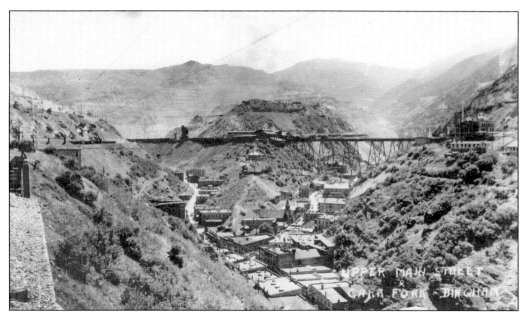

This is a great image to show how Bingham Canyon is divided, to the right up to Highland Boy and the left to Copperfield. This corner could be considered the heart of Bingham, with the veins running to the smaller communities around it. The buildings and businesses around this spot became landmarks that everyone knew.

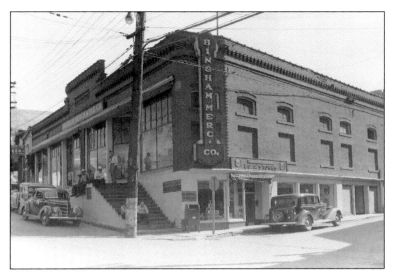

What anchored this place was the Bingham Mercantile store, on the corner of Main Street and Carr Fork. Everyone knew this store, and many did their shopping here. This was the location where one waited for a ride up or down the canyon. It was a gathering place, where people gave speeches and bands played. Abbott and Costello and Shirley Temple sold war bonds here.

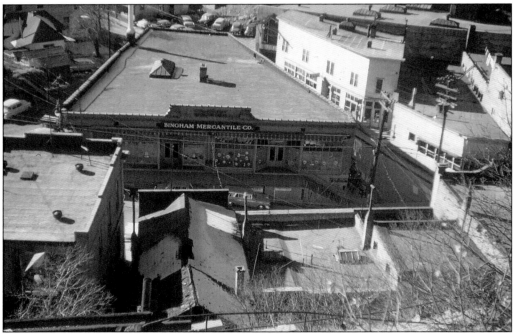

This image shows the Bingham Mercantile. Charles Adderley and his partners established the Bingham Mercantile in 1897. It outgrew its first location in a year, and the next store was by Social Hall. Adderley bought out his partners' shares and built a new store on Carr Fork and Main Street in October 1904. The store's shape was designed to serve both canyons, and the roofline was distinctive; it is easily spotted in photographs.

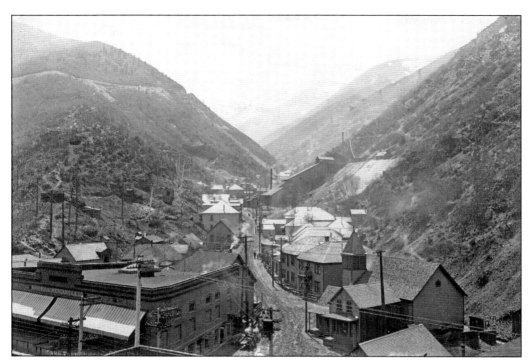

This is an early image of Bingham Mercantile, where one could buy almost anything, from a safety pin to blasting powder. The street level was for the grocery and meat department, the Main Street level was for clothing, and the basement on the Carr Fork side had a barbershop as well as other leased spaces. The store employed 18 people and grossed $250,000 a year. Charles Adderley was reportedly a good man; he helped many people get through hard times.

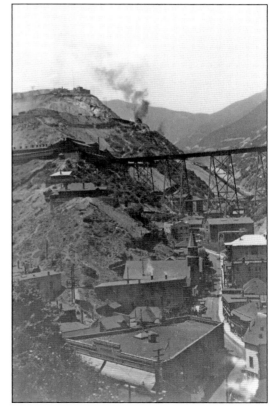

This image is looking up Carr Fork Canyon. The Bingham Mercantile, also called the "Bingham Merc," is visible at bottom center. The large Carr Fork Bridge dominates the canyon. The Utah Copper machine shop is perched on the mountainside, center left. Under the shop are the houses of Copper Heights. Up from the Bingham Merc is the Catholic church. The Gemmell Club is at the base of the Carr Fork Bridge, center right.

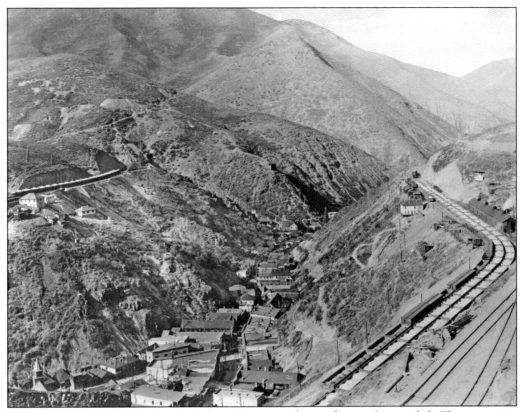

This photograph is looking down Bingham Canyon at the confluence, bottom left. The two major ore-haulage railroads are in view. The Cuprum railroad yard of the Rio Grande Western and its low-grade line are seen at right. The new Bingham & Garfield Railroad, seen left, started hauling ore in September 1911; this line eventually took over all ore haulage to the mills.

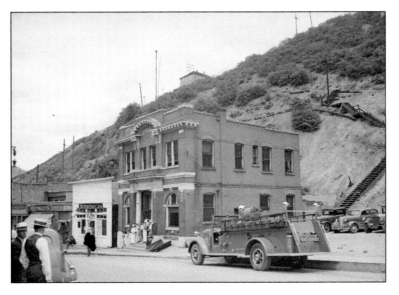

The city hall building in Bingham Canyon is seen here. The photograph was taken in 1939 with a fire truck in front. The jail was in the back. The building had a reddish-orange-color brick, and the color and architecture made the building stand out. The city hall building was erected in 1907, and it was around for a long time, as one of the last standing structures in Bingham.

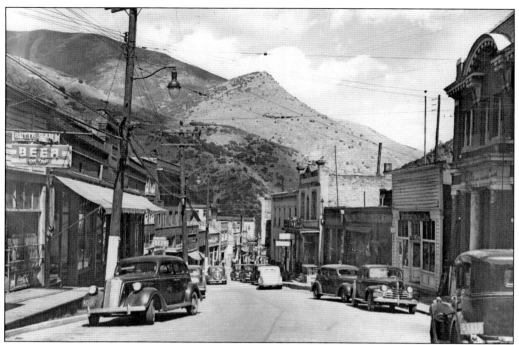

The city hall building is pictured at right. The businesses and buildings next to city hall running down the canyon are the Bingham Stage lines, SJ Hays men's clothing (toggery), and Bingham State Bank, which was the first bank in Bingham in 1903; the name changed in 1929 to First Security Bank. Moving down Main Street are Union Hall and Diamon Inn, with rooms upstairs and a pool hall and saloon downstairs.

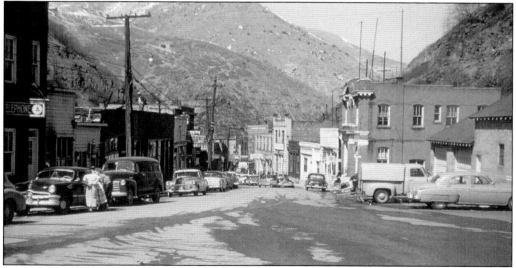

This view is looking across Main Street from the city hall building. The businesses running down the street on the left are the telephone company, a barbershop, and the Bingham Mercantile. (Note the man standing on the roof as the building is being demolished.) After crossing the road to Carr Fork Canyon, the businesses were the Copper King Bar, Vienna Café., Princess Theater, and the Pastime Bar.

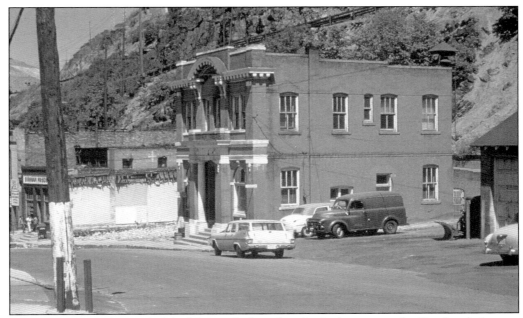

This image shows the city hall building with the jail in the back, center right. Bingham's days are numbered. The buildings left of city hall have been razed, down to the First Security Bank (now Bingham Museum.) In the late 1960s, the houses and buildings were being torn down one by one. This spot in Bingham was dug away by the open-pit mine.

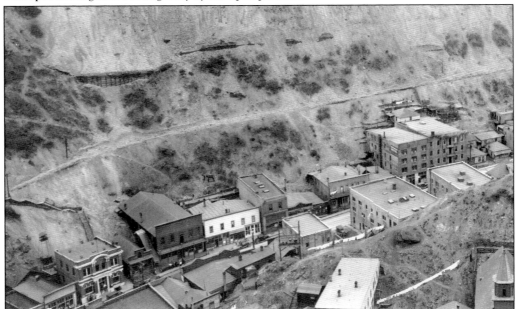

This photograph shows buildings running up the canyon that were once next to the city hall, bottom left. The buildings were torn down in 1937 to make way for the Copperfield tunnel. The ones that remained were eventually taken over by the expanding mine. Some of these establishments were the Bingham Hotel, Belmont Hotel, Knight Hotel, boardinghouses, the old California Hotel, and the Butte café.

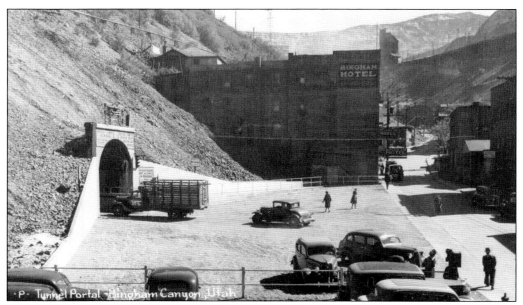

The mine was expanding to the east, and it was getting deeper but the road to Copperfield was in the way. In 1937, Kennecott started constructing the Copperfield tunnel, digging from both ends. The tunnel curved back into the mountain to give the mine room to grow. The tunnel was completed in December 1938. The first traffic through the tunnel took place was February 4, 1939.

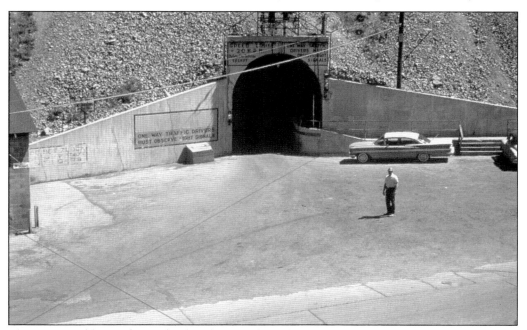

The Copperfield tunnel was a landmark in Bingham that everyone knew. When visiting the mine, people traveled through the tunnel to get to the observation platform in Copperfield. The tunnel was open to one-way traffic, and at each end, there was a signal light to control the vehicles' turn, up or down. There was a pedestrian walkway that was elevated from the road and a large fan for the fumes.

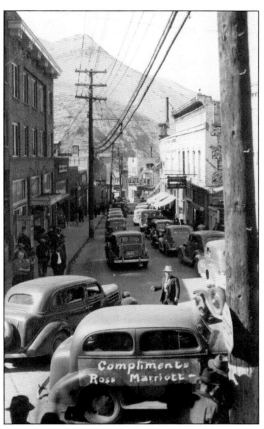

The confluence was a busy traffic place, especially around shift change. The man directing traffic is Ross Marriott, the chief of police. Marriott was a longtime resident of Bingham; he had a blacksmith shop in Frog Town. Note how narrow Main Street is and the steady stream of traffic. With all the cars parked on the side of the road, there was only room for one lane.

Seen here are the houses of Copper Heights. On the hill that separated the main canyon from Carr Fork Canyon, Utah Copper built six homes in 1917 called Copper Heights. The houses had landscaped yards with lawns and trees—a luxury in Bingham. The houses were built for Utah Copper executives and the foreman. The houses were reached by a steep road, seen center right.

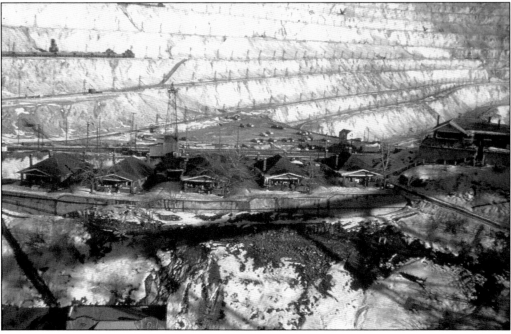

The view is looking west toward Carr Fork Canyon from the confluence. The Gemmell Club is up the street at the bend in the road. The Carr Fork, or A-line, Bridge looms over the town. From here on up, seven large viaducts will dominate the skyline. The Pappasideris Store (with a Royal Bread truck in front) is pictured at left, followed by the Catholic church, apartments, boardinghouses with wooden porches, and the George Klonizos barbershop.

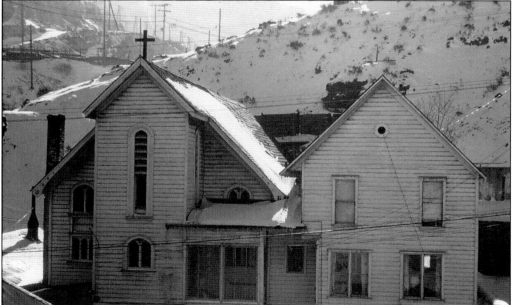

Seen here is the Holy Rosary Church in Carr Fork. In 1910, a new Catholic parish church was erected in Bingham Canyon, dedicated as the Holy Rosary Church. The rectory where the priests lived is to the right. Fr. John J. Sullivan was the last pastor; he celebrated the last Mass in the Bingham church in 1958, and then he oversaw the sale of the church and property to Kennecott Copper.

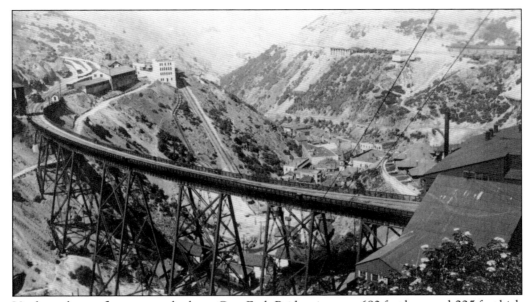

Up from the confluence was the huge Carr Fork Bridge; it was a 680-feet-long and 225-feet-high curved steel bridge completed in June 1911. It was also called the A-line bridge. The early mine levels were named letters. A-level (elevation 6,340) was the bottom level of the mine for many years. Note the town of Bingham on the canyon floor.

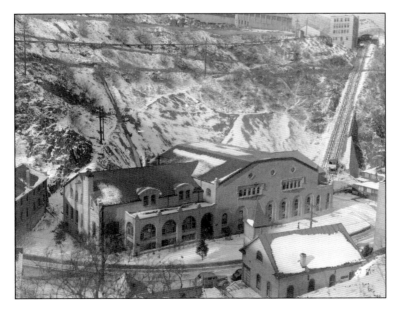

The Gemmell Club was built in 1923. The building's name was the Robert Campbell Gemmell Memorial. Robert Gemmell and Daniel Jackling were the two young mining engineers who ran tests on the Walls property to see if it could be profitable to produce low-grade copper. Gemmell became general superintendent of the mine and mills. He died in 1922 at the age of 59. The building was erected in his honor.

This picture was taken during the building of the vertical tram in 1911. The vertical tram was part of the Bingham & Garfield Railroad. At first, this railroad was a common carrier; it had passenger service to the mine from 1911 until 1921. To get the people down to the canyon floor, Utah Copper built this tram. It had a 21-percent slope with a 150-foot vertical rise pulled by a cable. One could also take the stairs, seen at left.

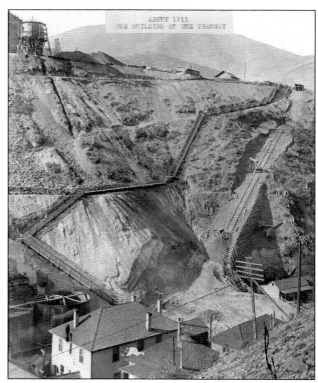

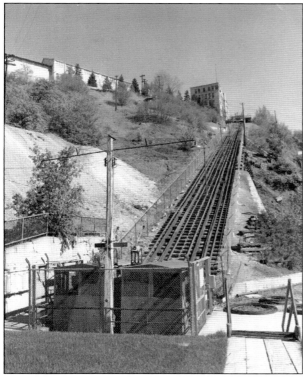

Seen here is the vertical tram to the Bingham & Garfield depot. After passenger service was discontinued in 1921, Utah Copper used the vertical tram to transport employees to the Bingham & Garfield train yard. Utah Copper constructed its mine office building up on the Bingham & Garfield yard, pictured top center. Warehouse No. 1 is top left. In the late 1970s, the tram, mine offices, and all of Bingham & Garfield's rail yard were removed.

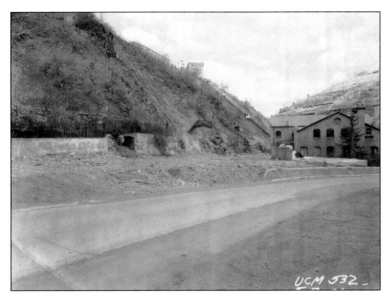

The Gemmell Club is at center right. All the buildings around it are demolished. In the late 1960s, the open-pit mine was expanding to the north, and everything in its path was removed. The Gemmell Club was taken over by Kennecott for the use of mine offices. The basement, where there was once a bowling alley, was used for ore core sample storage. The building was razed on December 17, 1976.

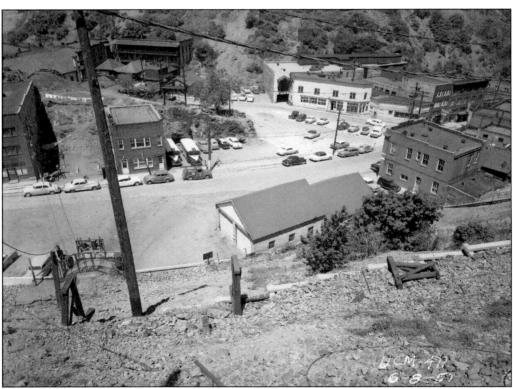

This view is looking down on the confluence on June 8, 1957. The spot where the Bingham Mercantile once was is now just an empty parking lot. The Bingham Merc closed its doors on June 23, 1956, and the building was razed in January 1957. Note the back side of city hall and the jail in the back, center right. Across Main Street, the telephone company's building is still standing, center left. Everything in view will soon be removed.

Eight
HIGHLAND BOY

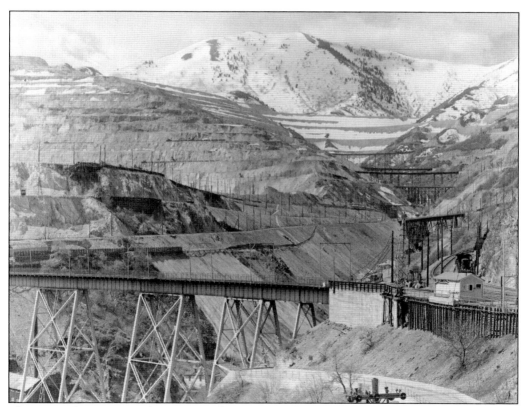

This image shows Carr Fork Canyon with its many bridges. The community of Highland Boy and the Highland Boy Mine is at the top of Carr Fork Canyon. Starting with the Carr Fork Bridge, there were seven large viaducts or bridges crossing the canyon; one is blocked from view in this photograph. Numerous people lived in this high, tight, and narrow canyon.

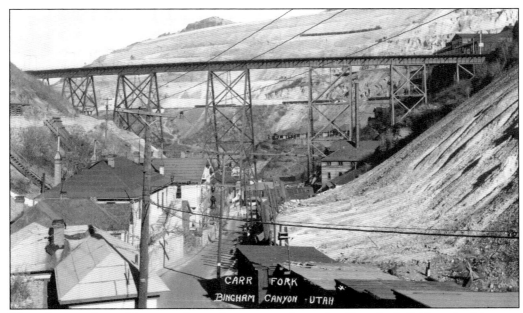

This photograph, looking east down the canyon, shows the Carr Fork Bridge. At this spot, the community was called Carr Fork; it was just up from the confluence. The houses and boardinghouses line the narrow street. Note the cribbing holding back the mountain. Carr Fork and all of Bingham was a study in cribbing, as it was everywhere and used everything to hold back the mountain.

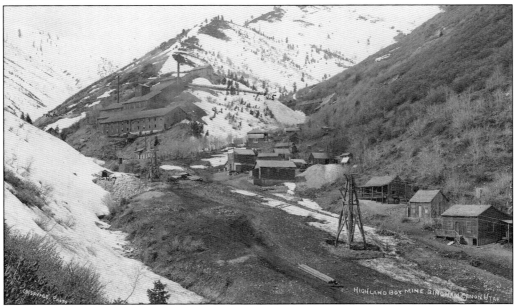

This is an early view of the Highland Boy Mine, seen at the top of Carr Fork Canyon. The Highland Boy claim was located in 1873. Samuel Newhouse purchased the property in 1896, and it became Utah Consolidated Gold Mines. It was the first chief copper-producing mine at Bingham. In 1899, John D. Rockefeller of Standard Oil bought a controlling interest; it then became Utah Consolidated Mining Company.

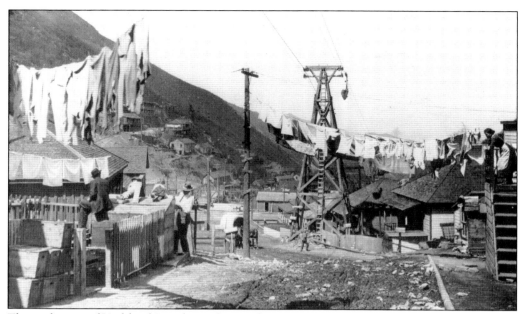

This early view of Highland Boy shows the aerial tram towers, lines, and buckets running through the community. It must be Monday wash day, as clothes hang across the street. The wagon coming up the road and the man standing next to the aerial tram tower offer perspective on how big the aerial tram towers were. Note how the houses are built up on the mountainside in the background.

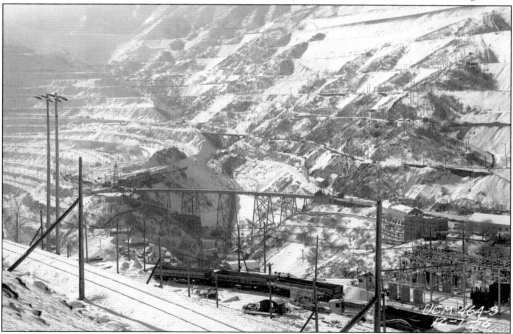

This wintery view is looking up Carr Fork Canyon and to the bridges. The first bridge, the Carr Fork Bridge, was part of the Bingham & Garfield Railroad main line to the mills. The next bridge up the canyon is the D-Line bridge, the only straight bridge up Carr Fork Canyon. The bridge was unique, being made of half wood and half steel.

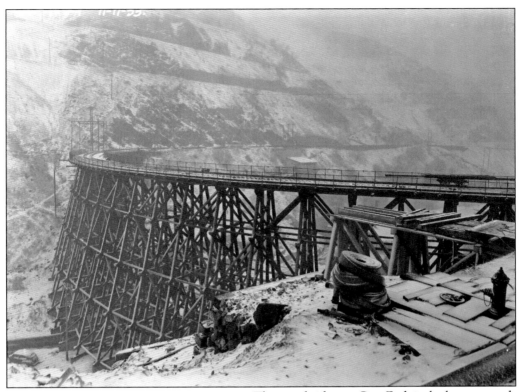

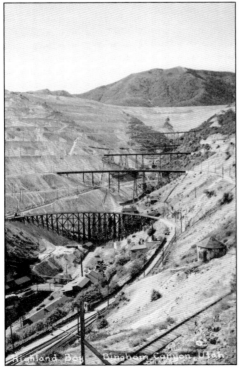

The next bridge up Carr Fork is the large, curved wooden G-line bridge, built between 1924 and 1925. In 1953, the south end of the bridge was straightened. Utah Copper owned the property on the south side of Carr Fork. Utah-Apex owned the north side of Carr Fork. In 1924, Utah-Apex granted surface rights for dumping grounds to Utah Copper. This is when bridge construction up Carr Fork started.

This image is looking up Carr Fork Canyon toward the G-line, H-line, and I-line bridges. The H-line and I-line bridges were built in 1939. Both were curved steel bridges and could be called viaducts. Both were 140 feet high, and the H-line was longer at 610 feet in length. All the bridges up Carr Fork, except for the Carr Fork Bridge, were used for waste trains.

Pictured is the construction of the I-line bridge. The I-line bridge was 590 feet in length. The H-line and I-line bridges looked so similar that the only way to tell them apart was to look at the buildings and houses at their bases. The I-line bridge had the famous Highland Boy Community House on the north side, and across the canyon on the south side was the Armstrong tunnel and mines complex.

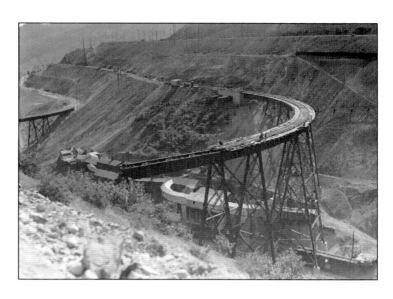

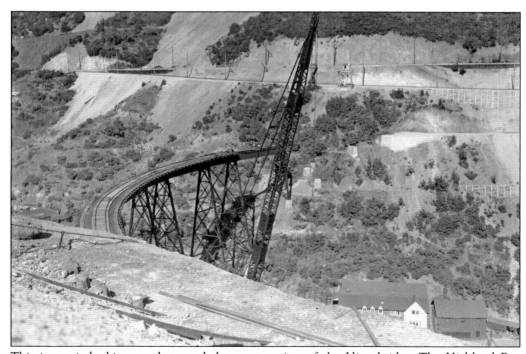

This image is looking north toward the construction of the I-line bridge. The Highland Boy Community House, visible in the bottom right, served as a worship and recreation center for everyone. Ada Duhigg, deaconess and ordained minister of the Methodist Church, was one of the leaders. She served the Highland Boy community, lending a hand during the many disasters that impacted the area. She was referred to as "the Angel of Highland Boy."

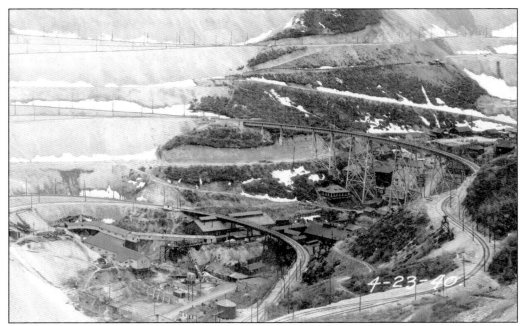

The photograph shows the short J-line and the large L-line bridges. The J-line bridge was built so short, it cut through the roof of one of the buildings of the Highland Boy Mine, bottom center. These bridges were busy day and night, as they were used for hauling waste material across to the north-side waste dumps. The houses and buildings were constructed right underneath them.

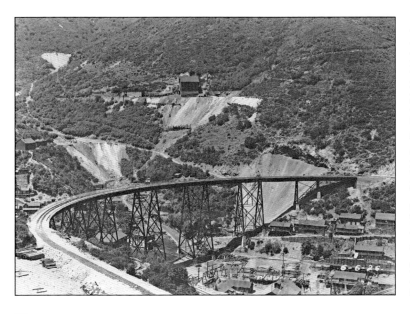

This image, dated June 6, 1926, shows the impressive L-line bridge, the last bridge up Carr Fork. Bridges were named after their corresponding levels; A and B were levels in the mine, and V level was the highest. The house in the center of the L-line bridge supports, with the lawn, belonged to the superintendent of the Highland Boy Mine. Sap Gulch is at center left.

This is a photograph of the aerial trams in Highland Boy. Before the large bridges filled Carr Fork Canyon, there were aerial trams, with three up the canyon. Utah Consolidated Mining Company (Highland Boy Mine) had an aerial tram from 1897 to 1910. In 1910, the tram changed direction, moving west and crossing over the Oquirrh Mountains to the International Smelter in Tooele. The Yampa and Apex Mines also had aerial trams.

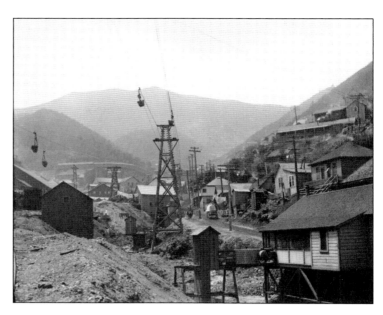

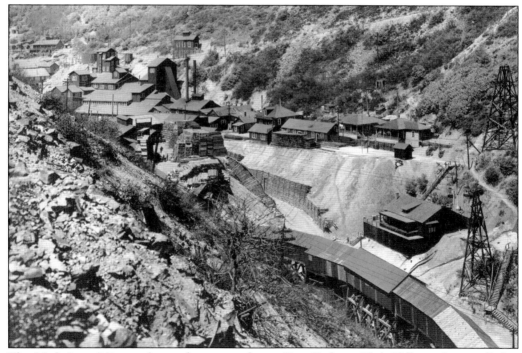

The Utah-Apex Mine and complex was in lower Carr Fork on York Hill; residents called it "Phoenix." By the early 1900s, the claims around Bingham were being consolidated, and mines were being purchased by large organizations like the Utah-Apex Mining Company. The Yampa Mine merged into Utah Consolidated Mining Company. The Yampa Mine built a smelter in the canyon at Frog Town, and an aerial tram brought ore from the mine right into the smelter.

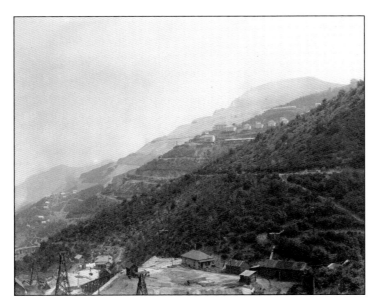

This image shows Boston Consolidated housing high on the mountainside, center right. Samuel Newhouse sold the Highland Boy properties to John D. Rockefeller; with the funds, he purchased 51 mining claims high on the south side of Carr Fork. Boston Consolidated was organized in November 1898 and was the first to start open-cut mining at Bingham. It was an era when one had to live close to one's work.

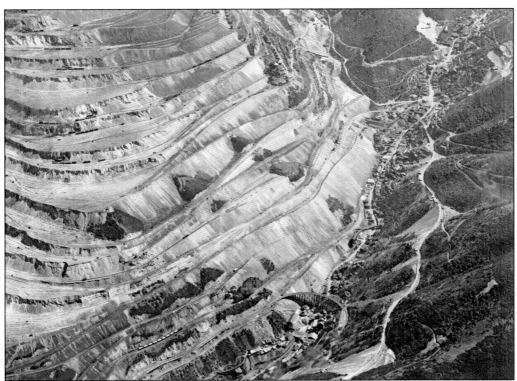

This is an aerial view of Highland Boy and Carr Fork Canyon. In this photograph, taken in 1925, only the G-line and J-line bridges are shown. Houses and buildings line the canyon floor, with homes built on the hillside. The mine levels run up the mountainside, pictured left. The Boston Consolidated housing with dorm-like houses and two-story boardinghouses is at top center. Boston Consolidated housing was consumed by the mine shortly after this image was captured.

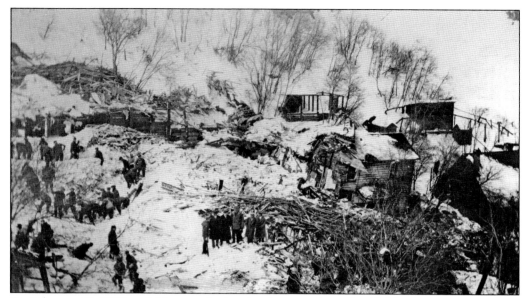

On February 17, 1926, at 8:00 a.m., a bad avalanche came down Sap Gulch, destroying everything in its path. McDonalds boardinghouse and 17 homes were devastated, and 39 people were killed and 15 injured. It had been snowing for three days in one of the worst snowstorms in Utah's history. Workers from both Utah-Delaware and Apex Mines came to help.

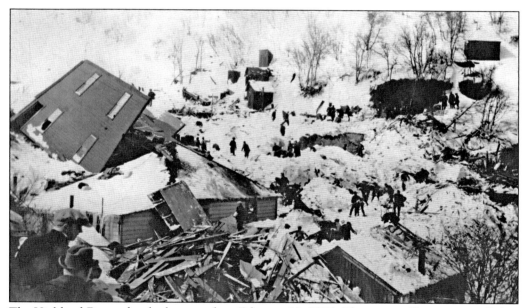

The Highland Boy avalanche happened on February 17, 1926. The rescue effort went on all day; floodlights were set up so the rescue could go on into the night. Some of the injuries were caused by fire from the wood-burning stoves. It seemed that the Highland Boy area was prone to disaster—floods, mudslides, fire, and now a snowslide. Maybe the steepness of the canyon or overcrowding was to blame.

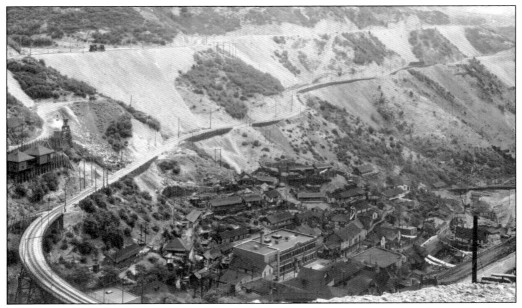

The photograph shows Highland Boy just below the J-line bridge. Pictured is the Highland Boy grade school, educating students in grades first through sixth, and next to it is the building that housed the Princess Theater, seen center right. Everything in this photograph was destroyed in the 1932 fire. Note all the houses stacked up on the hillside—all or most are made of wood.

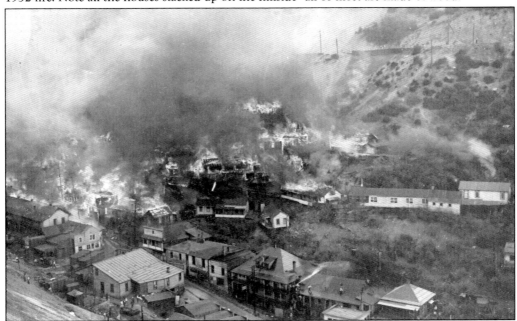

The Highland Boy fire started on September 8, 1932, at 3:20 in the afternoon. Smoke and then fire came out from the old, abandoned Princess Theater, spreading rapidly through this wooden community. Firefighting was hampered by low water pressure. Fire chief John Creedon had the Bingham Creek blocked off and used a pumper truck. With help from the Murray and Salt Lake County Fire Departments, the fire was brought under control at 6:00 p.m.

The fire destroyed everything one-third of a mile down the canyon. The Highland Boy grade school was completely gutted, and all 126 students and 4 teachers got out safe. The school's estimated value was $150,000. Over 100 homes and buildings were destroyed. The community, already hit by the Depression, now had 300 people homeless. The people of Highland Boy came together and helped, finding housing, clothing, furniture, and money.

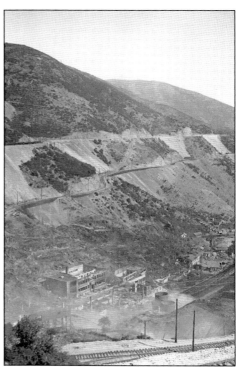

This road winds up to Highland Boy on September 11, 1938. Houses and boardinghouses line the road, and there are only a few on the hillside. After the 1932 fire, many homes will not be rebuilt. Many of the houses are obscured from sight. Clothes hang across the street. Note all the cribbing at center left. This view is looking all the way up to J-line and L-line bridges. The Mary Sam boardinghouse was owned by Mary Samon. It is at bottom right.

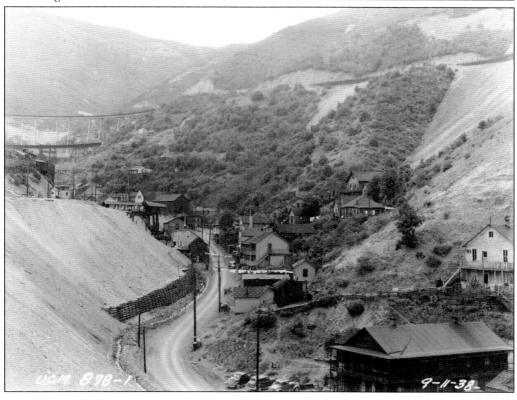

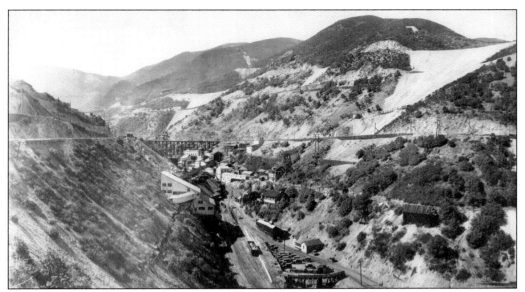

Pictured are the Utah-Apex Mine, loading station, and railroad yard. In lower Carr Fork Canyon, below the G-line bridge, there was the large Apex loading station, center left. The loading station has been around for a long time, becoming just a shell of what it used to be. The Apex railroad yard is at bottom center. Utah-Apex Mine contracted with Utah Copper to move its ores.

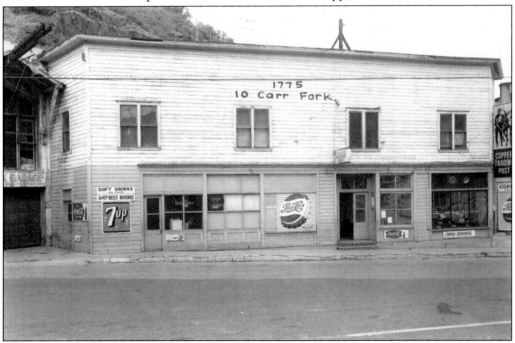

Seen here is the Trading Post souvenir and gift shop. This June 15, 1960, photograph was taken all the way back down Carr Fork Canyon at the confluence. The Trading Post store moved down to Lead Mine shortly after this was taken. The store will take the Trading Post sign with it, seen center right. All residents living in homes owned by National and Metal received eviction notices effective on June 7, 1957, effectively ending Highland Boy.

Nine
COPPERFIELD

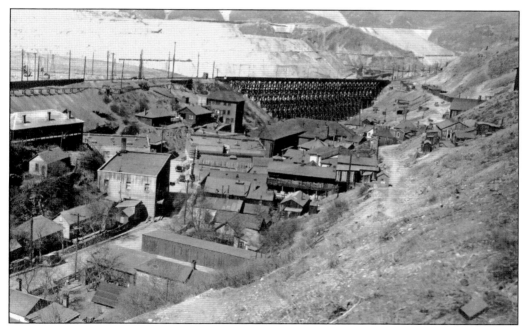

This image is looking down on the community of Copperfield to the large E-line bridge. This large, wooden trestle separated the mine from the little town of Copperfield for many years. A smaller curved E-line extension bridge was built in 1907 and then replaced by the larger straight E-line bridge in 1912. The bridge was built to access dumping grounds on the east side of the mine.

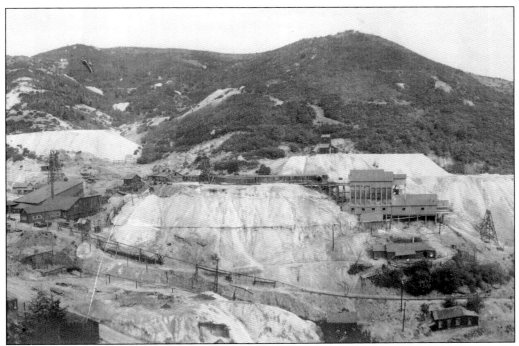

United States Mines Company's upper aerial tram terminal building is seen here. Farther up the canyon, the road split right to Galena Gulch and left to Bear Gulch. Galena Gulch was home to the first mining claim at Bingham in 1863, the old Jordan Mine. The United States Mines Company purchased these claims and more in 1899. It built an aerial tram to Frog Town that ran from 1902 to 1914; this upper terminal building serviced the Jordan and Galena Mines.

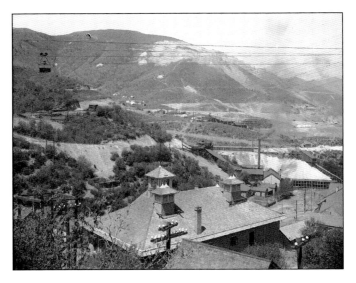

Copperfield Grade School, the first grade school in Copperfield, was constructed in 1908, opened in 1909, burned down in 1918, and was then rebuilt. The school had a furnace and inside bathrooms. Note the overhead cables and buckets from the United States Mines Company's aerial tram. The company's Niagara tunnel, mine dump, and compressor house with smokestacks are above right. Utah Copper and Boston Consolidated Copper are beginning open-cut mining, seen in the top right.

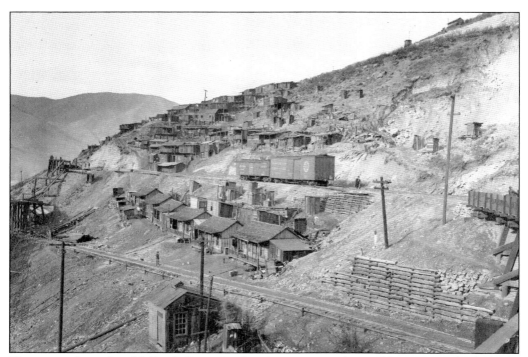

This image shows the old Greek Camp. Finding housing was a big problem, so men built shacks and shanties on private property along the hill's sides. Some were built out of discarded blasting powder boxes. Many immigrants kept pouring into Bingham for work; by 1912, about 65 percent of the population was foreign-born. Greeks made up the largest nationality; an estimated 1,200 Greeks were in Bingham. (Courtesy of Utah State Historical Society.)

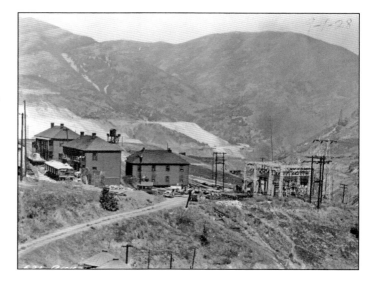

This is a photograph of the then new Greek Camp. The *Salt Lake Herald Republican* reported on the vile conditions of these powder-box houses. In their defense, these men lived a meager existence so they could send money home to their families. One year, it was reported that $508,000 in money orders were sent. In 1923, Utah Copper started reinventing the town. It built dormitory-type houses for those in the Greek community, respecting their way of living.

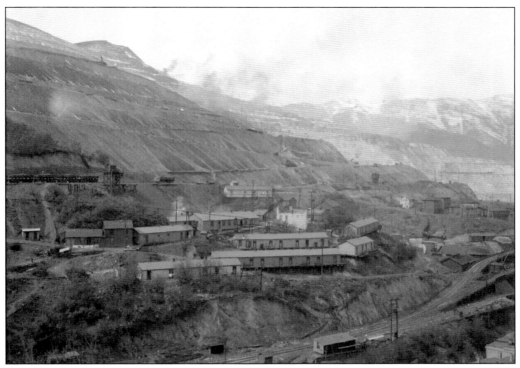

Seen here is the Japanese Camp in Copperfield. Japanese workers also wanted small, affordable apartments, so they could send money home to their families. During World War II, when Japanese people from all over the country were being interned in places like Topaz, Utah, those at Bingham were able to stay, live, and work. They were an important part of the war effort, with Bingham producing one-third of the nation's copper for the war.

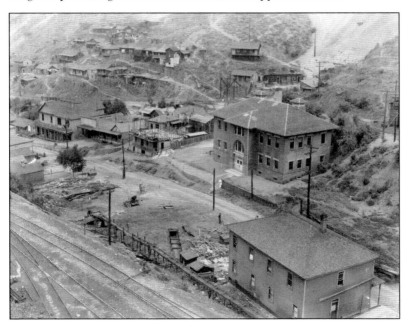

Copperfield Grade School is pictured at center right. All around the grade school, houses and buildings are being demolished. In 1923, Copperfield was being renovated up and down Main Street. Note the ramshackle types of buildings and shacks along Main Street and up on the hillside; they will be removed shortly. One building razed was the Odd Fellows Hall.

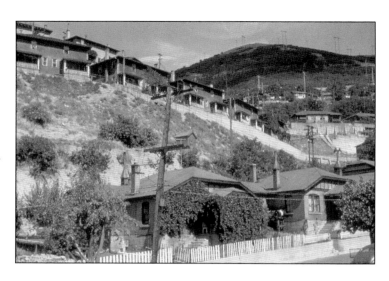

Utah Copper will build new cottage-type houses on Main Street. This later photograph shows the new houses Utah Copper and United States Mines Company built. They also built two-story duplexes (in Terrace Heights) and new houses in Dinkeyville, seen top right. Utah Copper and the United States Mines Company wanted a more stable workforce, so they started offering better housing.

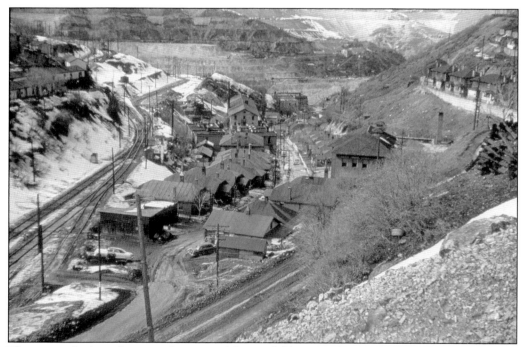

This view is looking down on the town of Copperfield. In April 1924, a total of 14 brick cottages started being built; by July 1924, Utah Copper had over 100 men building houses. The houses eventually extended all the way up Main Street to the grade school. In the early days, this area was called "upper Bingham;" in 1914, it incorporated, becoming Copperfield.

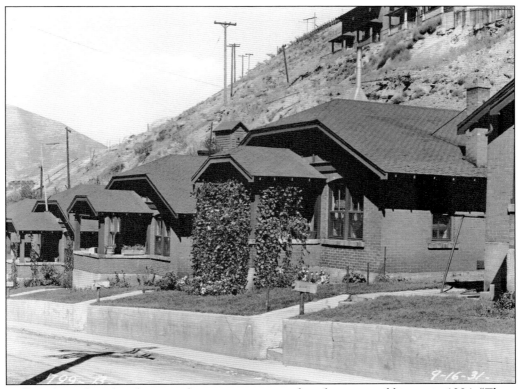

Arilla Jackson describes these new homes in an excerpt from her personal history in 1984: "These homes were well built, they consisted of a large living and dining room, a kitchen with built-in cupboards, with glass doors, and built-in sugar and flour bins. All the modern facilities, a full basement included a coal room, a fruit room and cupboard, a dirt room, used to store vegetables for winter."

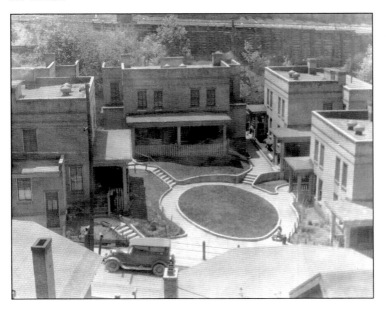

Seen here is "the circle," with apartments all around. A few names of people who lived here in the 1930s included Collier, Johnson, Cunliffe, Pierce, Bray, Nichols, McDonald, Steele, and Knudson. In the 1940s, the names included Burke, Bullock, Cunliffe, Baros, Pantalone, Ishimatsu, Malkos, Golish, and Callas. Later, some of the names included Caldwell, Gibson, Duran, and Romero. Note the car and the kids playing on the circle's walkway.

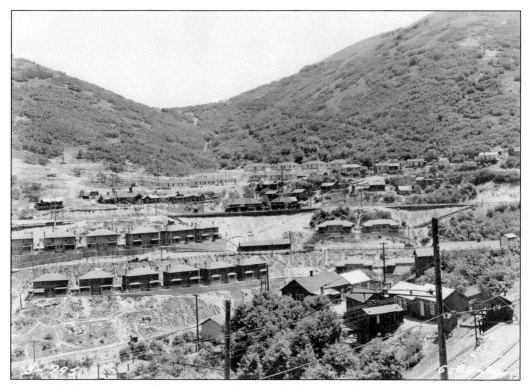

Terrace Heights is seen on the mountainside, center left. Around the same time, the brick cottages were being built down on Main Street in 1924. Utah Copper was constructing duplexes on the hillside, and this place was called Terrace Heights. The company was trying to build as much housing as it could close to work to reduce tardiness and absenteeism. Above Terrace Heights is Dinkeyville, and up the trail is "the saddle," top center.

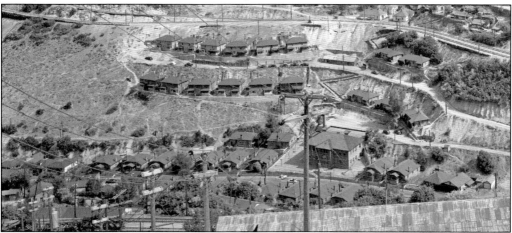

This is a close-up of the cottages on Main Street and Terrace Heights. The first phase of Terrace Heights was single-story duplexes, pictured right, followed by the two-story duplexes seen at center. This was on Terrace Road in Upper Terrace; more homes were added on Lower Terrace. Note the railroad tracks running above and through the housing of Terrace Heights at the top; this was the H-line that ran to the dumps.

Pictured is a close-up of the two-story duplexes of Terrace Heights. The pipes running down the hillside at left are storm drains. Winters were severe in Copperfield, and living on the steep mountainside, there needed to be a place for runoff water and melting snow to go. Note the open-cut mining coming closer above the duplexes, seen at top right.

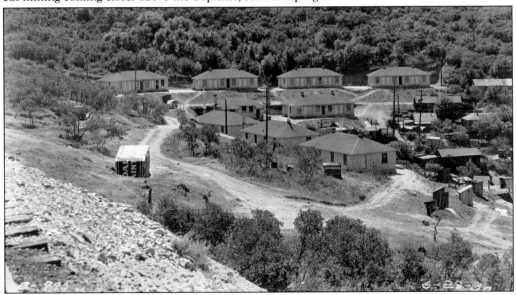

New houses are under construction at Dinkeyville on June 29, 1930. Dinkeyville was named after a small steam engine first used at the mine, called a "dinkey" (Porter steam engine). At Upper Copperfield near H-line, there was a rail yard called Dinkeyville (a whistle-stop). The name stayed when houses began being built here. Dinkeyville was high on the mountainside, and just above it was Copper Notch (called "the saddle"). Over the saddle were the Yosemite and Brooklyn Mines.

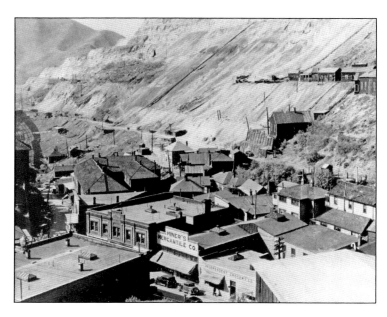

The photograph shows Miner's Mercantile and Independent Grocery. At the start of town, just past the E-line bridge, there were a few stores and businesses. Out of view was Mike the Barber, Joe Berger's Combination Bar, Pan-Hellenic Grocery, Byrnes Apartments, US Noodle House, Louie's Meat Market, and Cairo Club (a coffee shop). The Ohio Copper Company property is above left. Note a trace of the E-line bridge and its shadow, top left.

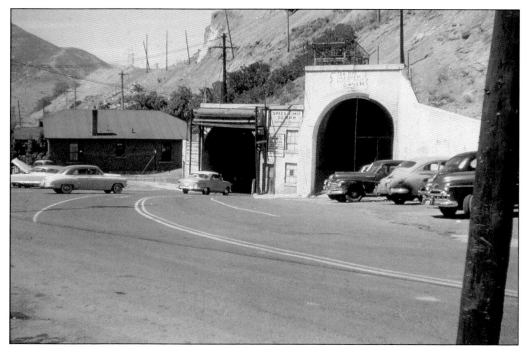

Seen here is the top portal of the Copperfield tunnel. The mine was moving east, and the road to Copperfield was in its path. In March 1937, the Utah Construction Company started digging a tunnel to Copperfield, with construction crews beginning at both ends and meeting in the middle. The tunnel went from an elevation of 6,100 to 6,600, with a four-percent grade inside. It curved east into the mountain for the mine's expansion.

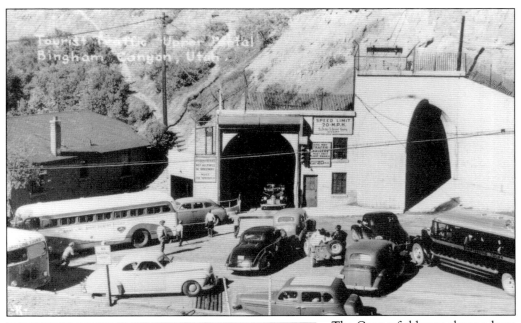

The Copperfield tunnel was a busy place. Traffic lights at both ends controlled the single-lane traffic through the tunnel. There was a large fan with doors that closed for exhaust fumes, seen center right. The Copperfield tunnel was opened to traffic in February 1939 but was not dedicated until September 30, 1939, at the first Galena Days. Copperfield was home to an observation point, where people could view the mine.

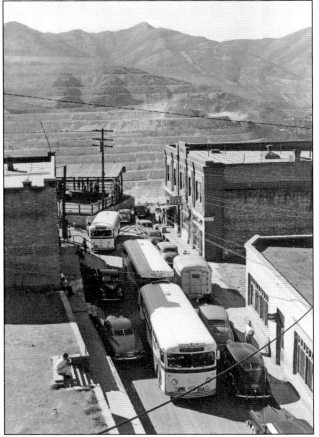

The busy observation point, or visitor center, in Copperfield is pictured here. Sometime after the county road was paved to Copperfield in 1928, the first observation point was built. It was at the base of the E-line bridge; after the E-line bridge was demolished in late 1940, a new covered platform was built, center left. Over the years, millions of visitors viewed the mine. It closed in October 1956.

The United States Mines Company's hotel is pictured at right. The United States Mines Company was right in the middle of Copperfield as was the Niagara Tunnel. In 1941, the United States Mines Company's operations started moving down to Lark, Utah. In 1952, with the completion of the Bingham-Lark tunnel, all the United States Mines Company's network of tunnels were connected, effectively closing mining operations in Copperfield.

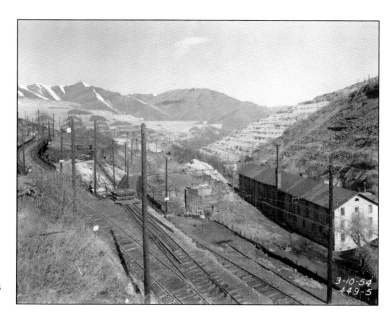

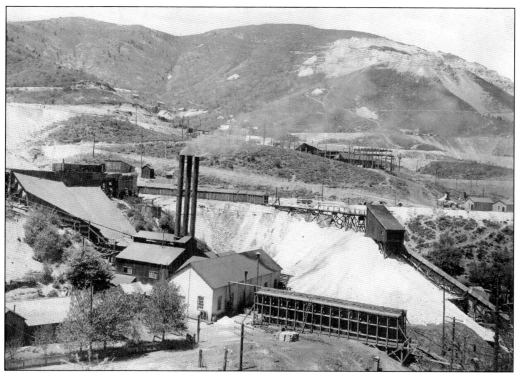

This is an early picture of the United States Mines Company's Niagara Tunnel. These three large smokestacks were a landmark in Copperfield for many years; they were built for the air compressor plant that made air for the mines. A system of pipes went up the mountain and into the mines to run the pneumatic drills. Some of the small ore train locomotives ran on air. Note the beginning of open-cut mining, seen top right.

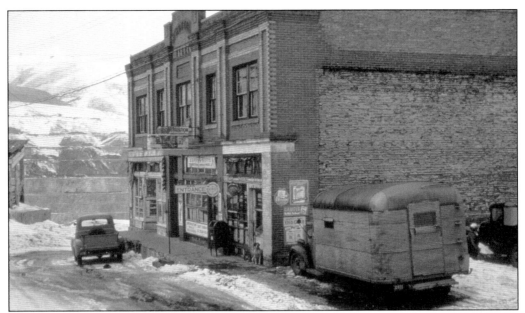

This image was captured during the last days of Copperfield. Seen here are the gift shop and the old Pan-Hellenic Grocery store, where the Greek immigrants were expected to shop. The padrone system was a network used by many immigrant groups to help them find work in the United States; it cost about $25–50 to get a job. Bingham's padrone was Leonidas Skliris, who also charged men a monthly fee to keep their jobs and insisted that they shop at his Pan-Hellenic Grocery store.

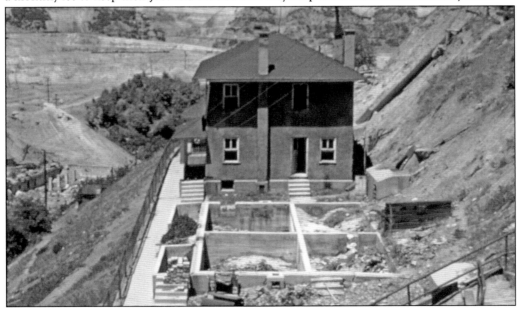

Terrace Heights duplexes are being demolished. Copperfield's days are numbered, as the mine is moving this way. On July 26, 1948, Kennecott purchased important rights from the United States Mines Company that allowed Kennecott to extend its open-pit operation south, eventually taking over Copperfield. The people who lived here loved Copperfield, but in 1958, Copperfield was dismantled.

Ten

THE PEOPLE

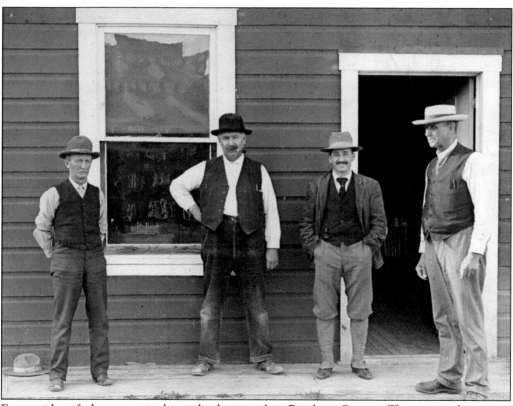

Four unidentified men are in this early photograph at Bingham Canyon. The trip up the canyon showed the places and towns that made up Bingham. The real story is about the people who lived and worked in this mountainous community. They came from all over the world and brought their own customs, religion, and determination to succeed. It is about the many nationalities that worked and lived together and created a bond that lasted forever.

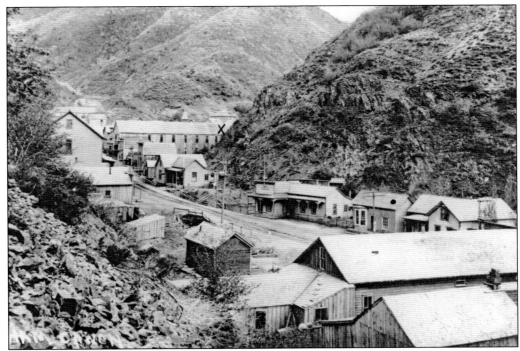

This image is looking up Main Street. Early Bingham Canyon was a mining camp that had a rough and tough reputation. There was gambling, prostitution, drinking, occasional bank robbery, and shootings, but mostly, men were arrested for being drunk in public and put in jail overnight until they sobered up. The jail was behind the city hall building. The first town sheriff was Atha Williams, a small man with big nerve.

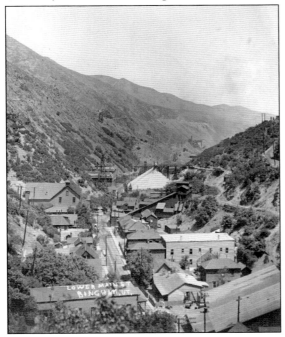

This view is looking down early Bingham Canyon. The first grade school and Bingham High School on the second floor of Canyon Hall are center left. Across Main Street are the Red Wing/Markham Mill and the Montana-Bingham mine and dump, pictured center right. In the distance is the old, abandoned Yampa smelter, pictured center right. Note the large aerial tram towers still on Main Street.

Early open-cut mining at Bingham was labor-intensive. Steam locomotives needed the engineer, brakeman, and fireman; the steam shovels had the operator, fireman, and oiler; and the track gangs had to keep building rails in front of the shovels (first shovels moved on rails) as well as move the tracks closer to the level after each shovel pass. There was also the drill and blasting department and many more workers.

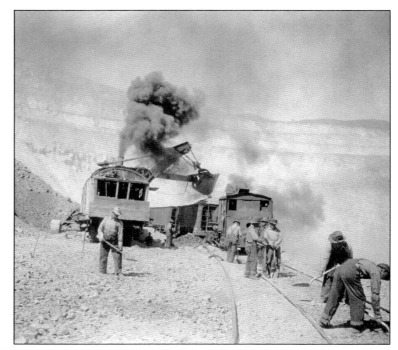

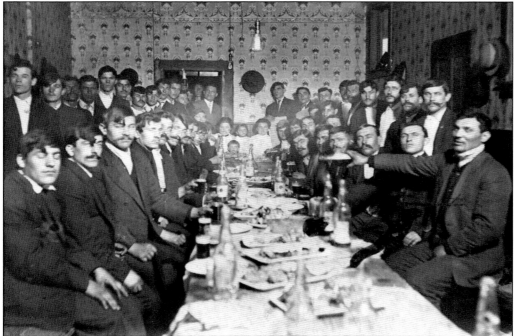

Pictured is a baptismal dinner at Highland Boy in early 1900 with Balkan immigrants; this group is Yugoslavs. Note the three girls at the end of the table. At the turn of the 20th century, there were not many women at Bingham Canyon. More women came over the years to work in the boardinghouses, hotels, and other establishments. Men sent for their wives and families when they earned enough money. (Courtesy of Utah State Historical Society.)

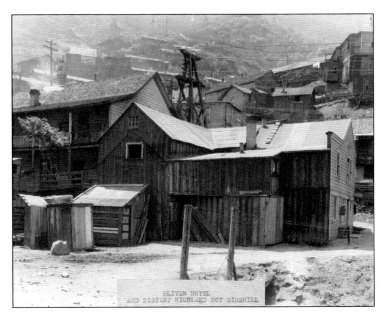

Seen here is the Bliven Hotel in Highland Boy. Boardinghouses and hotels filled early Bingham Canyon. The men working in the mines needed a place to eat and sleep. Many lived in boardinghouses; not only did the landlord provide meals, but many did their washing and ironing as well as served as nurses, doctors, and bankers. Boardinghouses became the center of their lives, as they hosted dances, parties, and a gathering place to talk and argue.

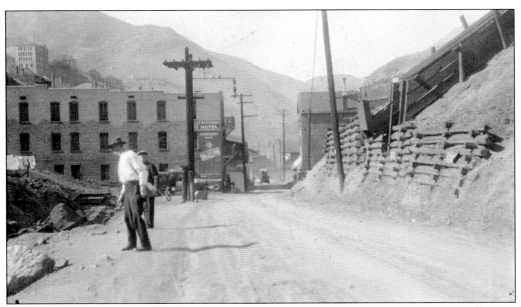

The California Hotel was just up from the confluence on Main Street. These men are walking to work, and the first man has a work bag over his shoulder. It was an era when one had to live next to their place of work. There were stairs and paths around the levels of the mine to gain access to the jobsite. This road led to Copperfield until the tunnel was built in 1939.

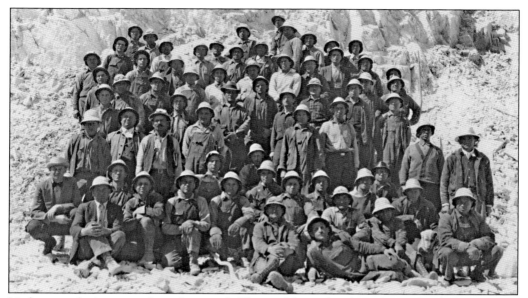

Underground miners pose for a photograph. The need for workers brought in a flood of immigrants to Bingham; Greeks, Serbs, Creates, Slovenes, northern Europeans, Norwegians, Swedes, Finns, Italians, Japanese, Britons, Scandinavians, French, Irish, Puerto Ricans, Mexicans, and many more came with the demand for cheap labor. The first safety rule books had to be printed in multiple languages.

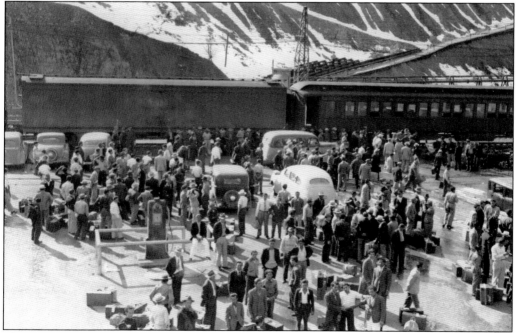

This passenger train at the Bingham & Garfield train yard brings in Puerto Ricans to work at the mine in this photograph taken in the 1940s during World War II. With many employees going off to war and with the Bingham Canyon Mine producing as much copper as it could for the war effort, Kennecott brought in more workers. Women also were hired to work at the mine during the war.

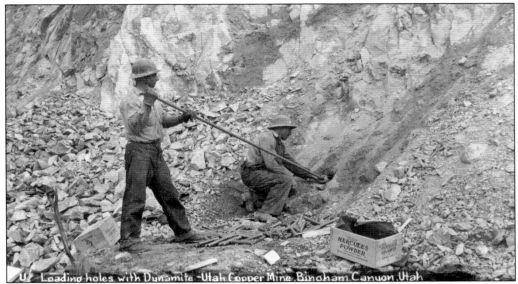

These workers load a drill hole with dynamite; stick after stick is shoved in the drill hole by the man with the long stick while the other man feeds in each stick of dynamite. The drill and blast department jobs were hard and dangerous, and usually, they were done by Mexican workers. Over time, with better equipment and techniques, this became a better job. Note the blasting powder box at bottom right.

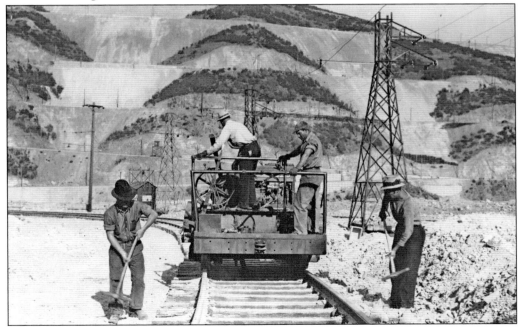

Seen here is a track shifter and track gang. The track gang was an entry-level job for new employees. It was hard physical work that had to be done every day. After the electric shovel made a pass digging the level and loaded as many ore cars as it could, the railroad track had to be picked up and moved next to the level again. This was done by the track shifter by clamping it onto the rail and moving it.

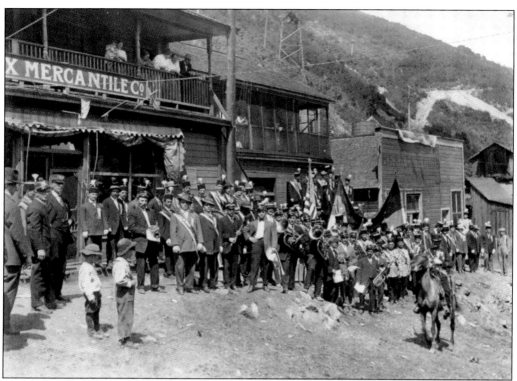

Seen here is Obilich and Dushan Serbian Lodge in Highland Boy in front of the Apex Mercantile. The immigrants moved into this strange new world of Bingham. They held on to their customs and language, and that was not easy. The immigrants had their own holidays they celebrated. One thing the people of Bingham had in common with them was that they all loved to celebrate. (Courtesy of Utah State Historical Society.)

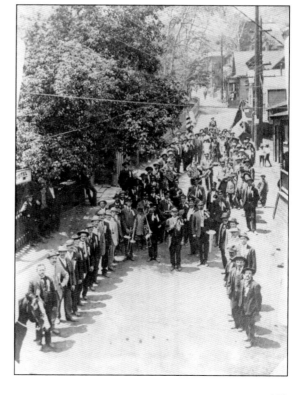

A parade of the Italian lodge comes down Main Street in 1909. Note both the US and Italian flags. The people of Bingham loved to party and did so every chance they could, celebrating the Fourth of July, July 24 (Pioneer Days), weddings, and even funerals. There was a big celebration at the end of World Wars I and II. (Courtesy of Utah State Historical Society.)

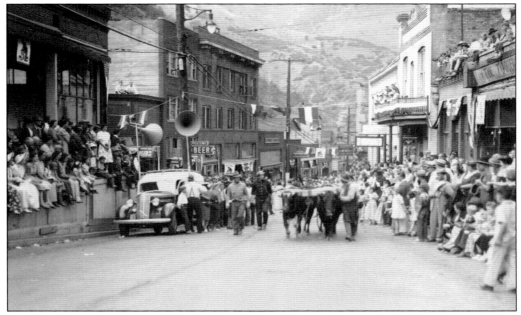

The Galena Day parade comes up Main Street at the confluence. The people of Bingham had their own holiday: Galena Day. It was a holiday in which the old days and the 1904 incorporation of the town were honored. The first Galena Day was on September 30, 1939, and people dressed up like in the olden days; men had to have a beard or they were put in (play) jail. Bingham held a parade, games, and contests.

This view is from inside the newly completed Copperfield tunnel, as people and cars travel through it. The tunnel was open to traffic on February 4, 1939, and it was dedicated at the first Galena Day on September 30, 1939. Before the first traffic used the tunnel, the people of Bingham strolled through it. Note the incomplete pedestrian elevated pathway to the left. It looks as if the people are having a good time.

Seen here are Bingham Canyon Post Office employees. From left to right are (first row) Agnes Milner, Anthea Christensen, the Star Route driver, Ivy Hall, and Hazel Mills; (second row) Dee Johanson, Irvin Stillman, Jack Davidson, Earl James, Frank Carr, Joe Vranes, and John Creedon. They are sitting on the steps of the Bingham Canyon Post Office, located at 407 Main Street.

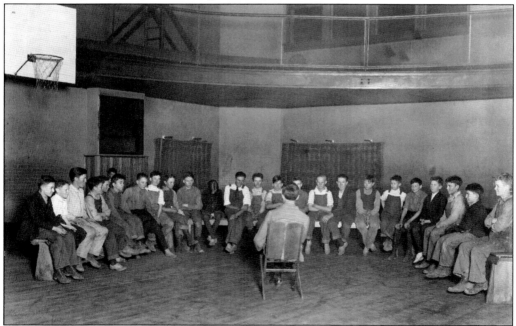

Bingham High School students had classes in the gymnasium, and later, the building became the civic center. The children of Bingham went to the same schools and played together, and it was the children that changed people's attitudes toward prejudice, bringing everyone together. The children played baseball and explored the mountains. The Highland Boy children used Carr Fork Bridge supports for "tricky bars." The Copperfield kids sold ore samples to the tourists.

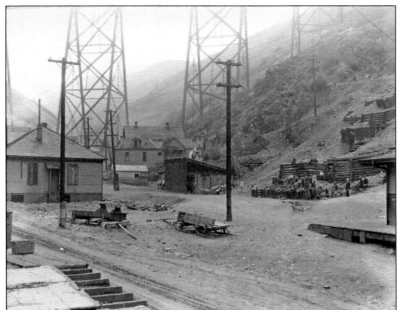

Children pose for a photograph after playing a game of baseball. It was hard to find a large open space at Bingham, and this spot was once the home of the old Shawmut mill. The space remained vacant for a few years until the Utah Copper company built the Gemmell Club here. Note the bridge supports of the large Carr Fork Bridge in the background.

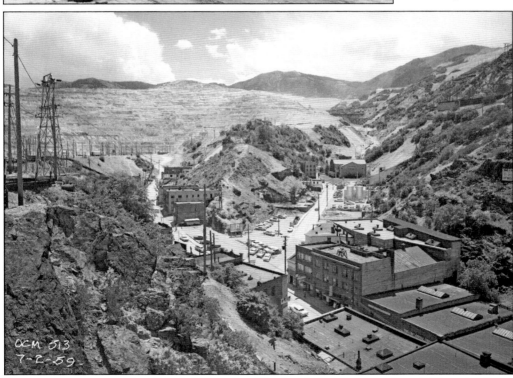

This image was captured on July 2, 1959, when Bingham's days were numbered. The mine keeps inching toward the camera, and the mountain that once separated the mine from Carr Fork Canyon is about gone. At the confluence, the spot where the Bingham Merc once was, is just a parking lot. The people are moving out and going to the valley to live. The people who lived in Bingham loved the place.

In Highland Boy on Christmas, neighbors would do a house crawl, tasting different ethnic foods and drinks. From left to right are Mary Yengich, Erma Yengich, Marko Yengich (standing), Gigita Louise Perelle, Nick Yengich, and Father Manuel. It appears that Mary is eating povitica. This photograph was taken at Larry Osoro's house by his mother in Highland Boy. This is a good example of the spirit of togetherness that Bingham would become. (Courtesy of E. Larry Osoro.)

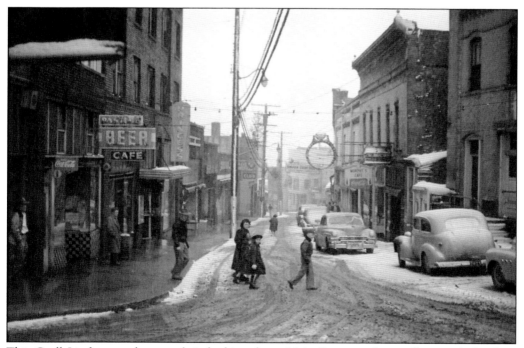

This Gaell Lindstrom photograph is looking down Main Street at the confluence. A family is crossing Main Street after a movie at the Princess Theater, center left. The narrow street, with Christmas lights hung across, the big ring sign, and the people walking, show that the place was alive. This photograph epitomizes what it was like to live in Bingham during the 1950s. (Courtesy of Braden Lindstrom.)

Discover Thousands of Local History Books
Featuring Millions of Vintage Images

Arcadia Publishing, the leading local history publisher in the United States, is committed to making history accessible and meaningful through publishing books that celebrate and preserve the heritage of America's people and places.

Find more books like this at
www.arcadiapublishing.com

Search for your hometown history, your old stomping grounds, and even your favorite sports team.

Consistent with our mission to preserve history on a local level, this book was printed in South Carolina on American-made paper and manufactured entirely in the United States. Products carrying the accredited Forest Stewardship Council (FSC) label are printed on 100 percent FSC-certified paper.